MW01091729

NATIVITY

Crèches of the World

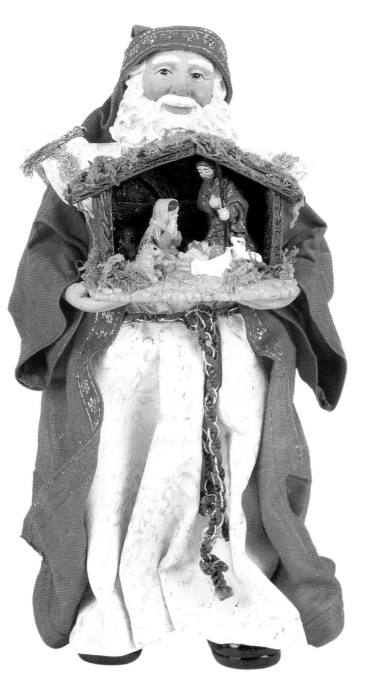

Leslie Piña & Lorita Winfield

Photography by Leslie & Ramón Piña

Schiffer Publishing Ltd

4880 Lower Valley Road, Atglen, PA 19310 USA

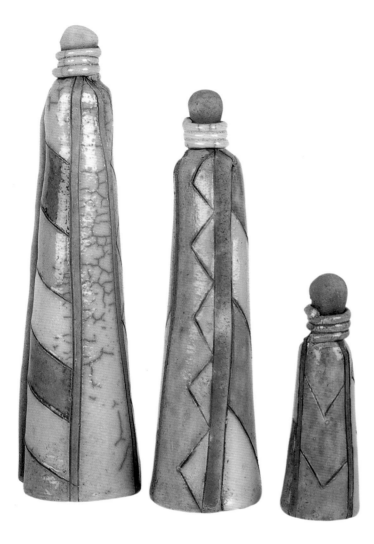

Front cover: Clay; one piece, Holy Family, Argentina, signed "Jujuy, 1998," 4 inches in height.

Back cover:
Top left: [slide #48-98] Clay; one piece, includes villagers and animals, manger depicted as hands of God, Peru, 6 inches in height.

Top right: [#37-176] Plaster, cast; one piece, includes four kings, villager, animals, African interpretation, Tanzania, 9 inches in height.

Bottom left: [#5-179] Glass, blown and lamp worked; 24k gold; three pieces, Holy Family, Murano, Italy, tallest figure 8 inches in height.

Bottom right: [#121-7] Wood; twelve pieces including kings, shepherd, and animals, marked "Made in Sri Lanka, VBI Inc.," tallest figure 4 ½ inches in height.

Published by Schiffer Publishing Ltd.
4880 Lower Valley Road
Atglen, PA 19310
Phone: (610) 593-1777; Fax: (610) 593-2002
E-mail: Schifferbk@aol.com
Please visit our web site catalog at
www.schifferbooks.com
We are always looking for people to write books on new and related subjects. If you have an idea for a book, please contact us at the above address.

This book may be purchased from the publisher.
Include $3.95 for shipping.
Please try your bookstore first.
You may write for a free catalog.

In Europe, Schiffer books are distributed by:
Bushwood Books
6 Marksbury Ave.
Kew Gardens
Surrey TW9 4JF England
Phone: 44 (0)208 392-8585; Fax: 44 (0)208 392-9876
E-mail: Bushwd@aol.com
Free postage in the UK. Europe: air mail at cost.
Try your bookstore first.

Copyright © 2000 by Leslie Piña & Lorita Winfield
Library of Congress Catalog Card Number: 00-104008

All rights reserved. No part of this work may be reproduced or used in any form or by any means—graphic, electronic, or mechanical, including photocopying or information storage and retrieval systems—without written permission from the copyright holder.
"Schiffer," "Schiffer Publishing Ltd. & Design," and the "Design of pen and ink well" are registered trademarks of Schiffer Publishing Ltd.

Designed by Leslie Piña
Layout by Bonnie M. Hensley
Type set in BernhardMod BT/Dutch801 Rm BT

ISBN: 0-7643-1212-X
Printed in China
1 2 3 4

Acknowledgments

We would like to express our thanks to Emma Lincoln and her family for generously providing the collection of Nativity scenes for us to photograph. In addition, we thank Sister Diana Stano, O.S.U., Sister Anna Margaret Gilbride, O.S.U., Sister Kathleen Burke, O.S.U., and Colleen Fritz, Ursuline College, Pepper Pike, Ohio. As we always do, we give special thanks to Peter and Nancy Schiffer, Jennifer Lindbeck, Bonnie Hensley, and the gang at Schiffer Publishing.

About the Collector

Emma Lincoln is an amateur photographer, an avid traveler, and a passionate, eclectic collector. She began her frequent and extensive travels around the world in the early 1970s. During those thirty years, she has packed her Hasselblad and her 16-mm Bolex to all seven continents and all twenty-four time zones. Along with the numerous rolls of exposed film, she has brought back folk and tribal art treasures from each one of her trips. In the last five years, Emma has converted to lighter weight equipment, a Leica 35 mm, and a digital video camera, and has begun to collect Nativity scenes from the world's cultures. Her first Crèche was made in clay and purchased in Mexico, followed by one made up in fine porcelain. These two diverse representations of the birth of Christ spurred her desire to acquire other cultural and artistic interpretations of the Nativity scene. The Lincoln family, which includes six children, eight grandchildren, and twenty-some cousins and relatives, gathers at her home during the Christmas season. Emma takes special care with holiday details, decorating every room, and displaying many special collections for all to enjoy. The collection of Nativity scenes is a recent addition to the festivities. Many of the Nativity scenes are new and were collected in the decade of the 1990s. Emma considers her large multi-cultural Christmas Crèche collection, now numbering over 250, one of her favorites and she will continue to add to it in the years to come.

All scenic travel photos are *courtesy of Emma Lincoln.*

About the Collection

Beginning with Christmas 2000, Ursuline College of Pepper Pike, Ohio, will present an annual exhibit of multi-cultural Nativity scenes. These exhibits are planned to enhance the holiday celebrations for the cities and communities of Northeast Ohio. The Lincoln family collection of Christmas Crèches inspired this book and the idea for the holiday exhibitions.

Foreword

At the beginning of a new century and during this Jubilee Year of the Church, as well as the sesquicentennial celebration of the Ursuline Sisters in Cleveland, Ohio, it seems appropriate to present the various artistic renditions of the true meaning of Christmas. The magnificent collection of Nativity sets by Emma Lincoln illustrates the universality of the Christmas message—God's love and forgiveness—we receive as a result of this holy event. May our lives also be an artistic expression of this love and reconciliation. May all who see this book and enjoy the beautiful pictures share anew in the blessings that Christmas brings.

Sister Diana Stano, O.S.U., Ph.D.
President
Ursuline College

Ursuline College Nativity.
Photo by Colleen Fritz.

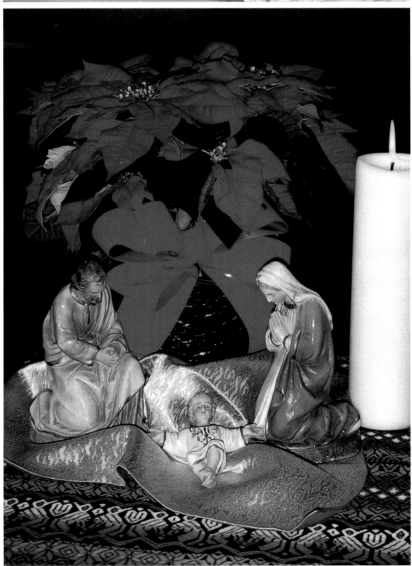

St. Angela Chapel,
Ursuline College. *Photo by
Sr. Kathleen Burke.*

Introduction

Crèche came into the English language from the old French word meaning "crib" and is now synonymous with the representation of the Nativity scene, the birth of Christ—including the crib or manger—the Holy Family, angels, kings, shepherds and villagers. In Italian it is known as *presepio*, in German, *Weihnachtskrippe*, and in Spanish, *naciamento*.

The tradition of the Christmas Crèche was inspired by the early Christians who made pilgrimages to the birthplace of Christ in Bethlehem. While representations of the Nativity appeared in religious art work as early at the fourth century AD, it was not until the sixth century that a church was dedicated to the Nativity. A small chapel in the basilica of Santa Maria Maggiore, in Rome, also known as *Santa Maria ad praesepem* (Holy Mary of the Nativity), became a place of worship. It contained relics from the crib of Bethlehem and wooden figures representing Mary, the infant Jesus, and Joseph. In the thirteenth century, artisans added the Magi to the scene.

Throughout the Middle Ages, costumed actors portrayed the "Nativity drama" as a part of the Christmas devotional celebrations. These Nativity plays were known as *Mysteres* in France, *Sacre Rappensentazioni* in Italy, *Misterios* in Spain, and *Geistliche Schauspiele* in Germany. According to the biography of Saint Francis of Assisi, in 1223, he recreated the drama using a baby, an ass, and an ox and transformed the village of Greccio near Assisi into a Bethlehem. By the end of the sixteenth century, Nativity dramas along with the religious "mystery plays" were considered unsuitable to be performed in churches because they had become too popular to be contained in a building. The dramas moved to the public squares and eventually faded as a tradition.

The demand for the Crèche did not diminish. In the fifteenth and sixteenth centuries, especially in Italy, artisans created scenes that were intended for display throughout the year. These Nativity scenes contained large figures of the Holy Family sculpted in wood, stone, or terra cotta, set in a "stage" painted to represent Bethlehem. During the same period, the religious order of the Jesuits promoted the display of Crèches in the niches and altars of their churches throughout Europe.

In the early seventeenth century, virtually every Catholic country had developed the tradition of the Crèche. Royalty, the aristocracy, wealthy families, and churches large and small, desired copies of Nativity scenes, which became increasingly more elaborate in detail. These scenes were treasured and enjoyed on display at "open house" during the Christmas season. The first family to have a private Nativity scene was in southern Italy. Owning a Crèche soon became the custom in the homes of Genoa, Sicily, and particularly Naples. These Crèches were designed and sculpted by skilled artisans and finished with the finest silks and precious stones and jewels.

Today, displaying the Nativity during the Christmas season is a popular tradition throughout the world. While the different cultural interpretations vary artistically, their common theme—the meaning of Christmas—is shared by all.

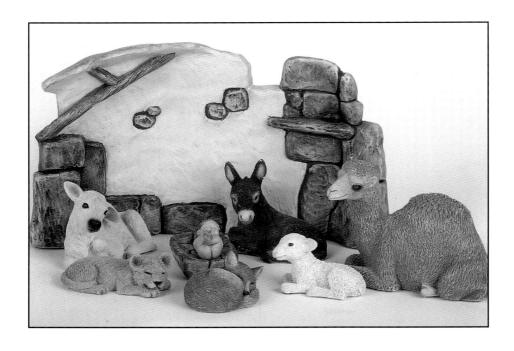

Opposite page;
Top: Crystal, cut and molded; silver plate, 24k gold; one piece, 11 attached figures including angel, kings, shepherds and animals, inspired by the artistry of Peter Carl Faberge, marked "House of Faberge, The Nativity," 7 inches in height.

And it came to pass while they were there, the days for her to be delivered were fulfilled. And she brought forth her firstborn son, and wrapped him in swaddling clothes, and laid him in a manger, because there was no room for them in the inn.

Luke 2: 6,7

Crystal, sculpted on reverse; one piece, Holy Family, Sweden, 6 inches in height.

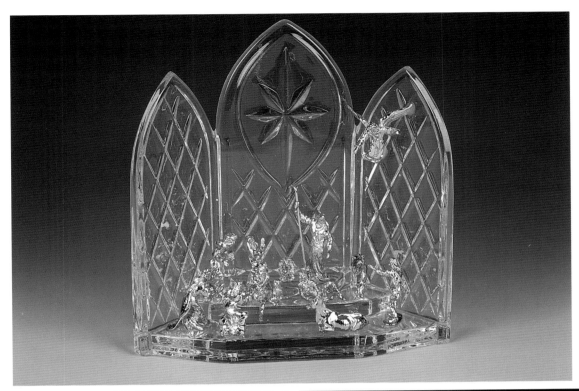

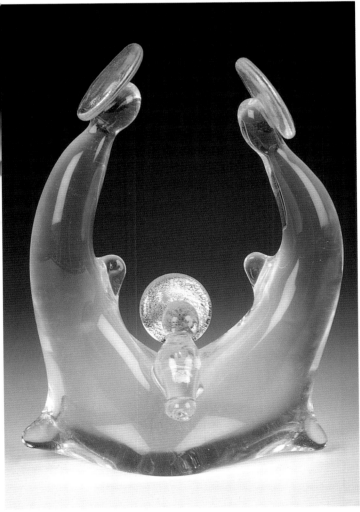

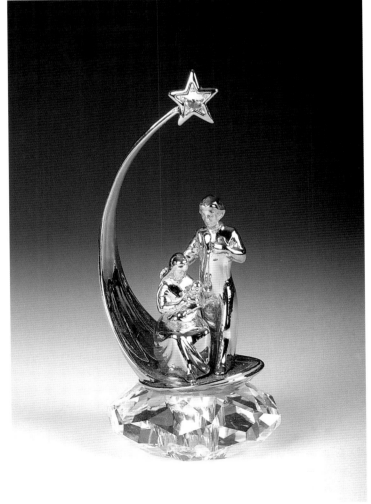

Glass, blown and lamp worked; 24k gold; one piece, Holy Family, Murano, Italy, 7 ¾ inches in height.

Crystal, 22k electroplated gold; one piece, Holy Family, Austria, 5 ½ inches in height.

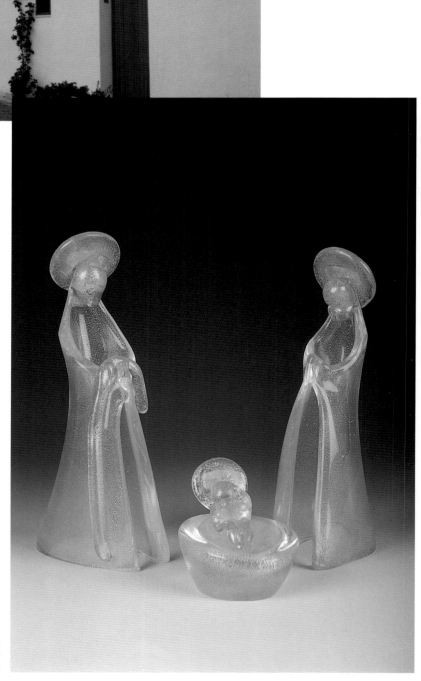

Glass, blown and lamp worked; 24k gold; three pieces, Holy Family, Murano, Italy, tallest figure 8 inches in height.

Top right: Crystal, molded and cut; pewter plated with 24k gold; three pieces, Holy Family, marked "Gorham," tallest figure 6 ½ in height.

Top left: Venetian glass, blown and lamp worked; 24k gold; multi-colored, millefiori ("thousand flowers") cane work, three pieces, Holy Family, Murano, Italy, tallest figure 6 ½ inches in height.

Bottom: Detail.

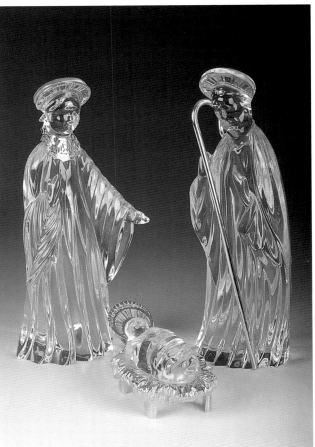

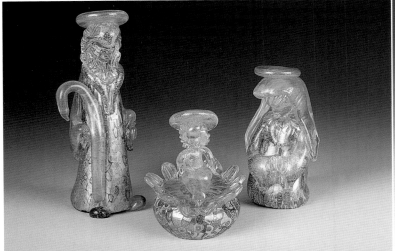

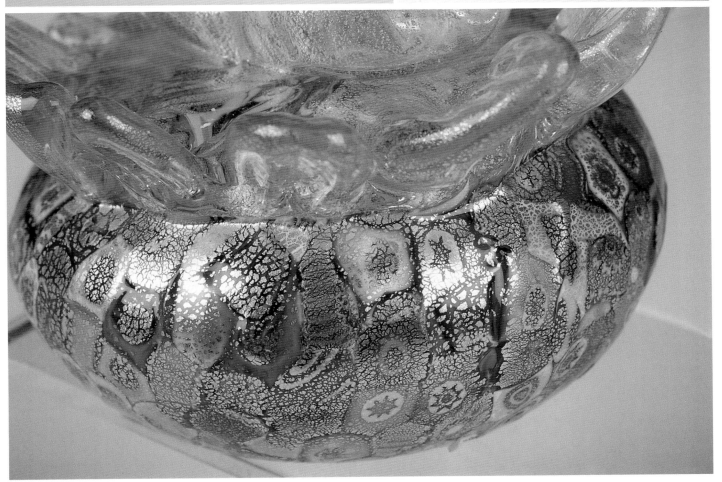

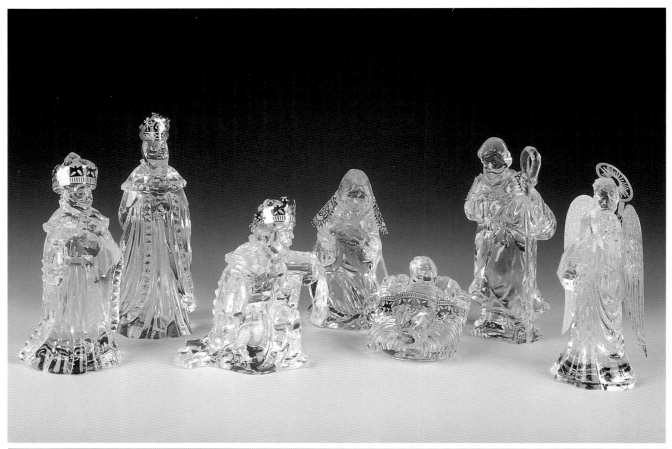

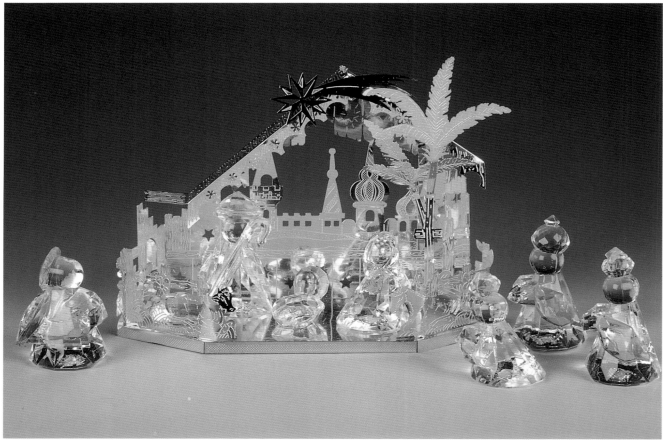

Top: Lucite, brass; eight pieces including angel and kings, tallest figure 4 ½ inches.
Bottom: Lucite, brass manger and background scene of Bethlehem; eight pieces including angel and kings, tallest figure 3 ¾ inches in height.

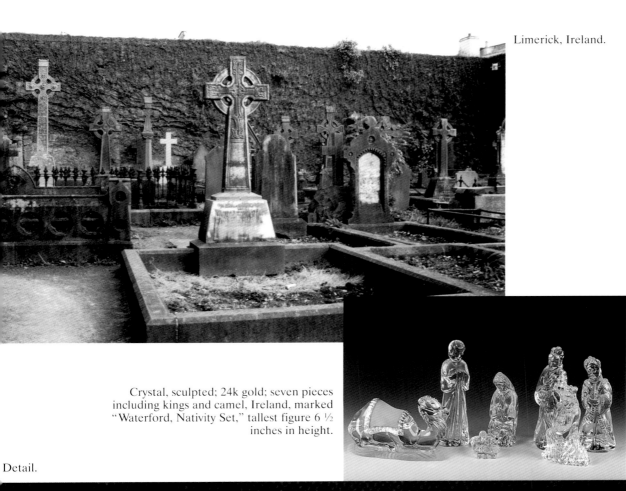

Limerick, Ireland.

Crystal, sculpted; 24k gold; seven pieces including kings and camel, Ireland, marked "Waterford, Nativity Set," tallest figure 6 ½ inches in height.

Detail.

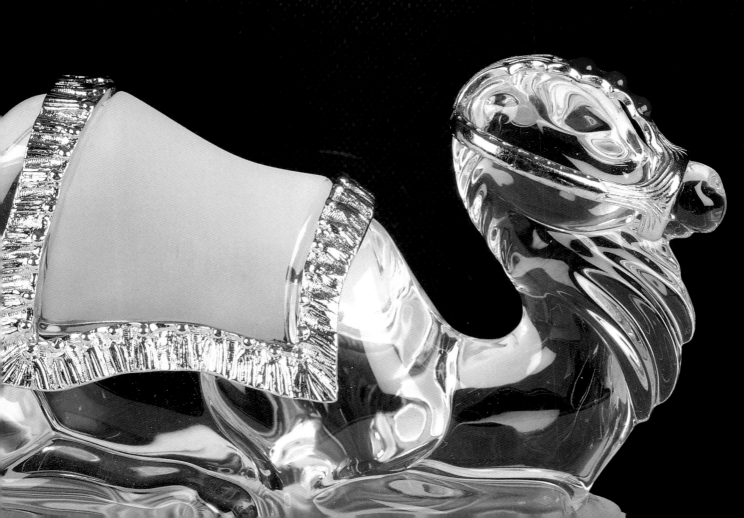

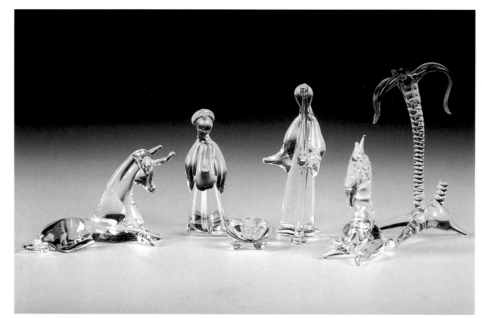

Glass, lamp worked; miniature, six pieces including camel, bull and palm tree, Venezuela, tallest figure 2 inches in height.

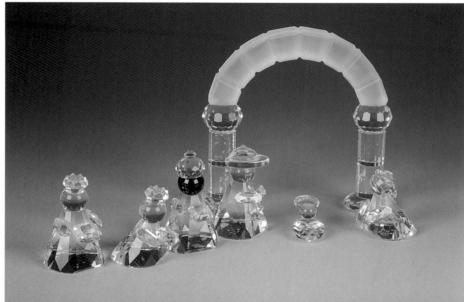

Crystal, cut; miniature, seven pieces including kings and an arch, by Swaroski, Austria, tallest piece 2 inches.

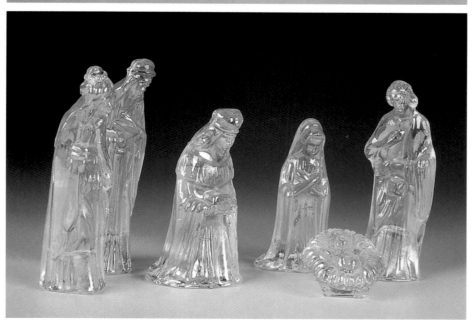

Plastic, molded, iridescent; six pieces including kings, tallest figure 4 inches in height.

Agrigento, Sicily.

Silver (800); miniature, eighteen pieces
including angels, kings, shepherds,
animals, Italy, tallest figure ½ inches.

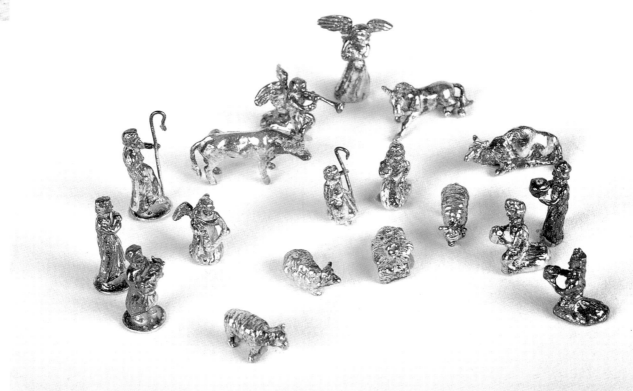

Lake Louise, Canada.

Pewter, textured glass; one piece votive (candle platform at back of glass), inspired by carvings at the Piazza del Duomo, Cathedral of Milan, Italy, with figures of Holy Family, angels, shepherd, marked "Seagull Pewter & Silversmiths, made in Nova Scotia, Canada," 11 inches in height.

silver (800); miniature, one piece including manger,
angels, kings, and animals, Italy, signed "G. Raspini,"
inches in height.

Sterling silver, 14k gold leafing; twelve pieces including kings, villagers, and animals, Italy, marked "Giardina Collection," tallest figure 8 inches in height.

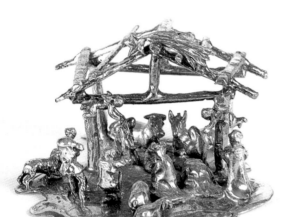

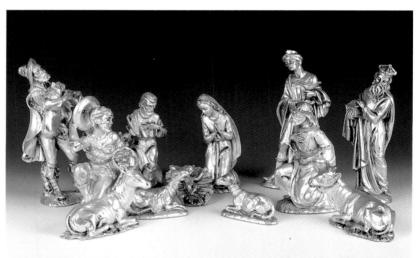

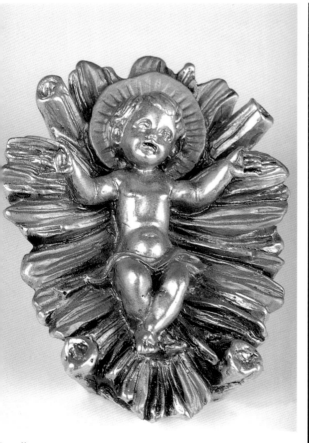

Detail.

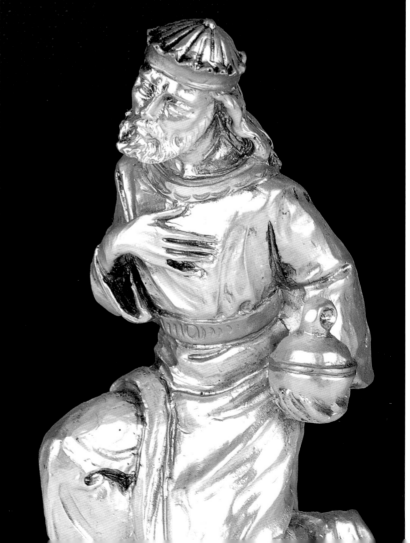

Detail.

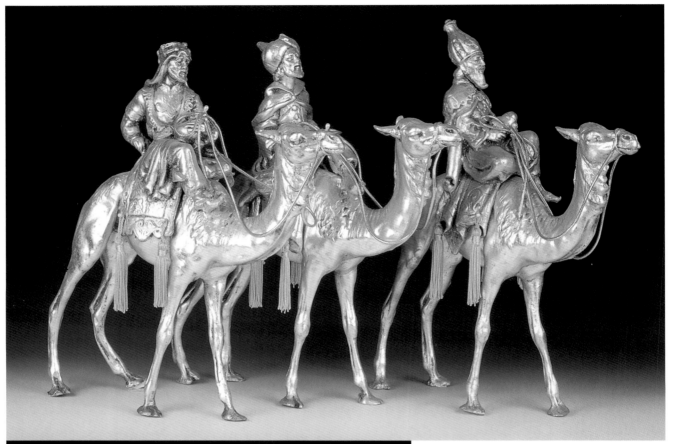

Composite, molded, laminated with gold and silver metallic; three kings on camels, 18 inches in height.

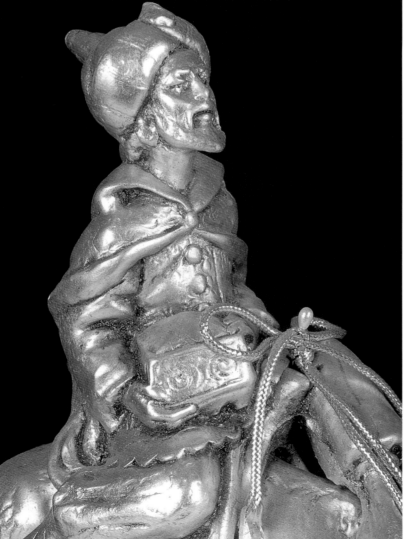

Detail.

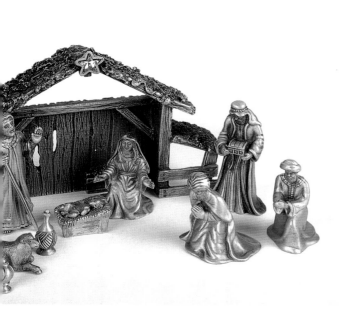

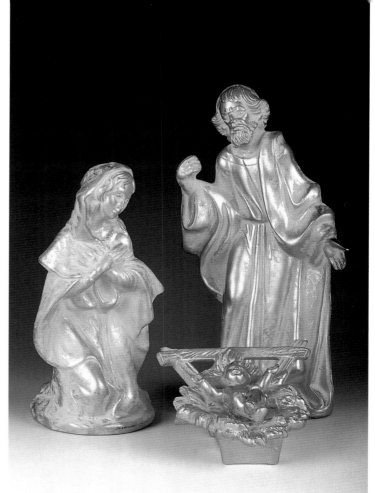

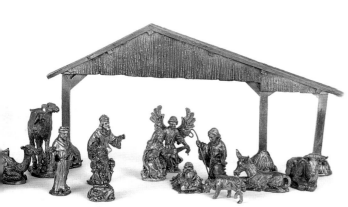

Top left: Pewter, gold vermeil; ten pieces including manger, kings, animals, and offerings, tallest piece 3 inches in height.

Bottom left: Pewter; fourteen pieces including manger, angel, kings, animals, marked "Handcrafted in U.S.A.," tallest piece 7 inches in height.

Above: Terra cotta, gilded; three pieces, Holy Family, marked "Jim Mariana Collection," tallest figure 10 ½ inches in height.

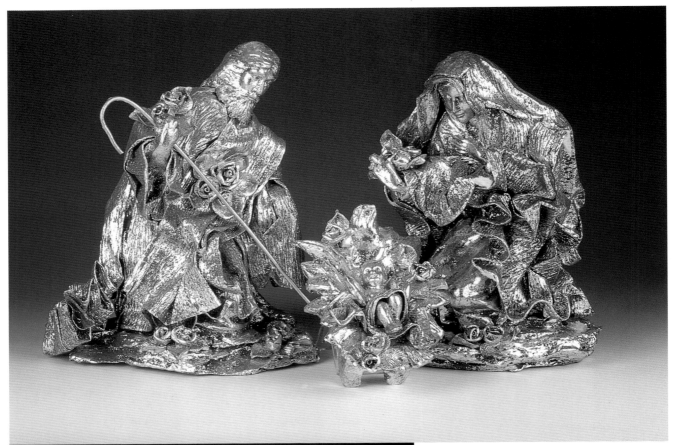

Paper, laminated with silver and gold; four pieces, Holy Family, marked "Silvestri," tallest figure 8 ½ inches in height.

Detail.

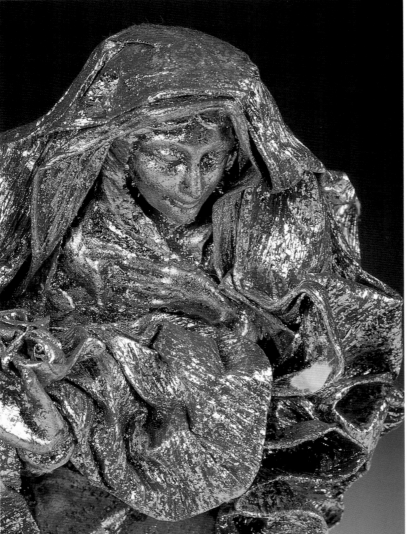

Opposite page
Top left: Porcelain; one piece, Holy Family, marked "1998 Roman Inc., Made in China," 4 ½ inches in height.

Top right: Soap stone, carved; miniature, one piece, Holy Family, 1 ¼ inches in height.

Bottom left: Ceramic; one piece, Holy Family, 3 ¼ inches in height.

Bottom right: Bisque porcelain, gilded; Advent candle-ring wreath of four curving pieces, with mounted figures including angel, kings, shepherds, marked "Midwest of Cannon Falls," 10 inches in diameter, tallest figure 5 ½ inches in height.

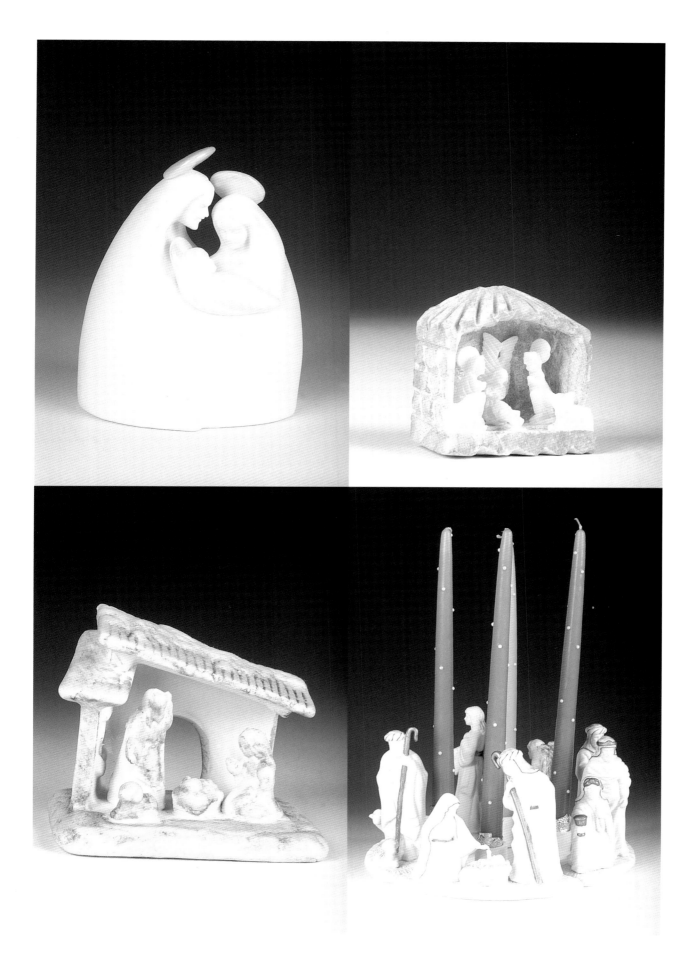

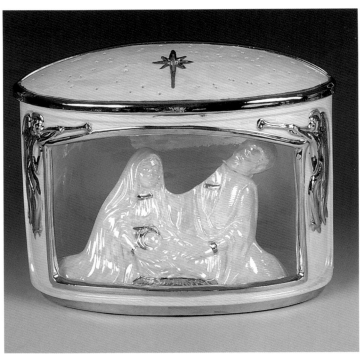

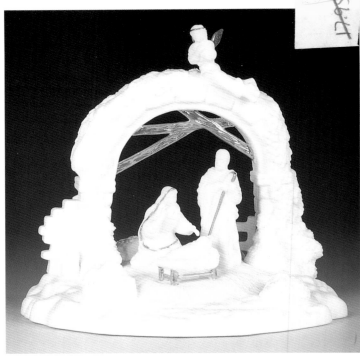

Porcelain, iridescent glaze, gilded; one piece
lamp, Holy Family, 7 inches in height.

Bone China, 24k; one piece, Holy Family, marked "The Holy
Night Nativity, Lenox '94, Bone China 1994," 8 ½ inches in height.

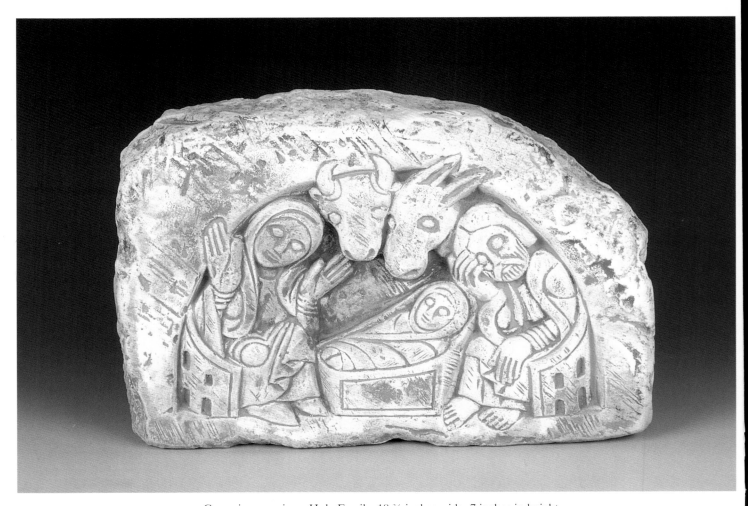

Ceramic; one piece, Holy Family, 10 ¾ inches wide, 7 inches in height.

*And behold, the star that they had seen in the East went before
them, until it came and stood over the place where the child was.
And when they saw the star they rejoiced exceedingly.*

Matthew 2: 9,10

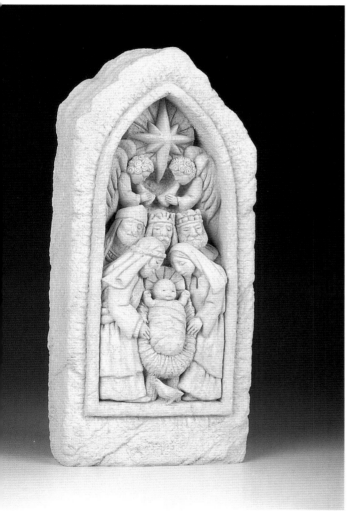

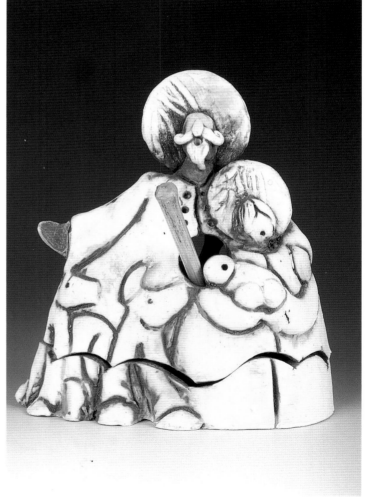

Concrete, hand-cast; one piece plaque, Holy Family, original in limestone and clay by George Carruth, marked "98 Carruth," 8 ¼ inches in height.

Clay; two piece incense burner, Holy Family, Venezuela, 6 ½ inches in height.

Masai Mara Reserve, Kenya.

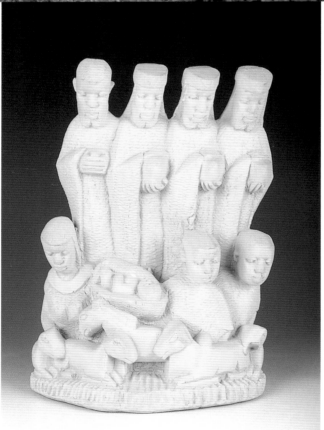

Plaster, cast; one piece, includes four kings, villager, animals, African interpretation, Tanzania, 9 inches in height.

Natural abaca fiber, wire, gold braid trim; one piece, Holy Family, marked "Made in Philippines," 5 ½ inches in height.

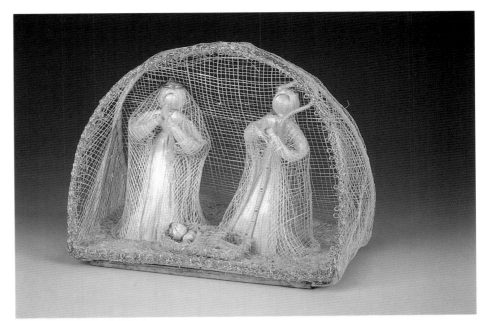

Clay, sculpted; one piece, includes kings, shepherds, and animals, 4 ¾ inches in height.

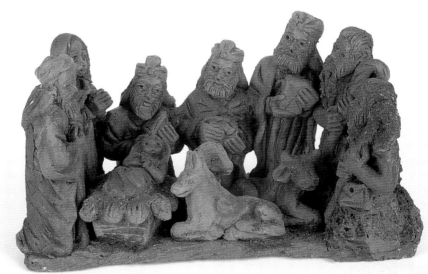

Wood, carved and pressed; one piece, includes kings, shepherds, and animals, Africa, 4 ½ inches in height.

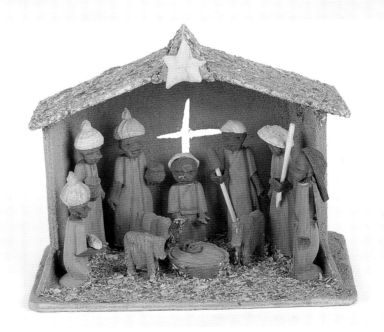

Pucara, Peru.

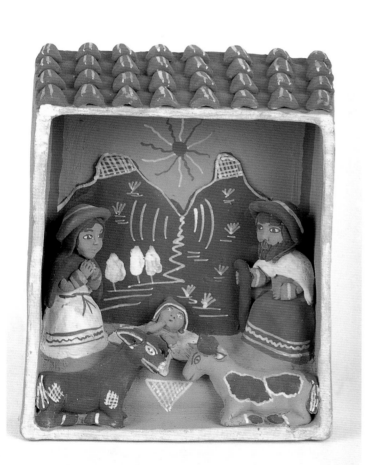

Clay, sculpted; one piece plaque, Holy Family, Peru, marked "B.Luck," 8 inches in height.

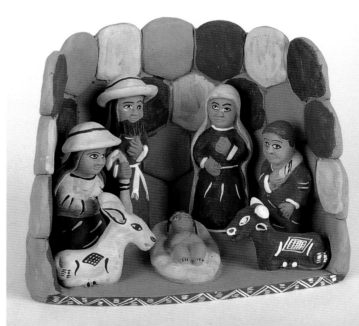

Clay, sculpted; one piece, includes villagers and animals; Quina, Peru, 5 ½ inches in height.

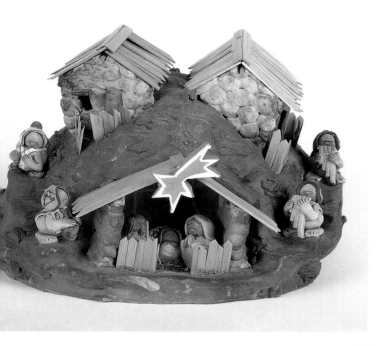

Clay, sculpted, wood; one piece, includes villagers playing musical instruments, Argentina, 4 ½ inches in height.

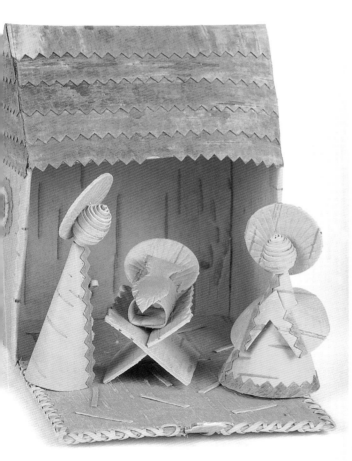

Birch bark; one piece, Holy Family, marked "Mermans K. 98," Russia, 4 inches in height.

Murmansk, Russia.

25

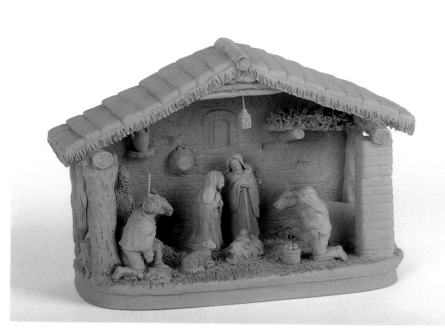

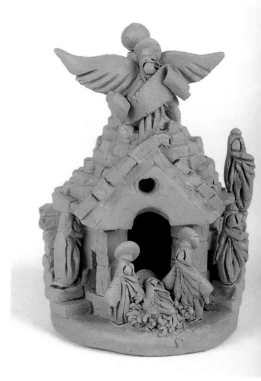

Terra-cotta, sculpted; one piece, Holy Family, Italy, marked "Vestita Michele, Studio D'Arte, Grottaglie," 5 inches in height.

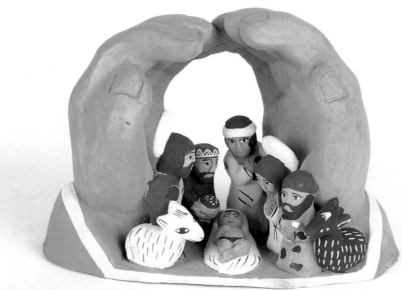

Top: Terra-cotta, sculpted; one piece, includes shepherds, animals, Venezuela (Italian influence), 8 ¼ inches in height.

Bottom: Clay; one piece, includes villagers and animals, manger depicted as hands of God, Peru, 6 inches in height.

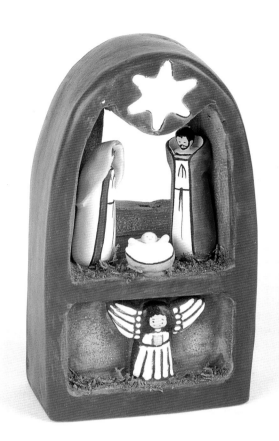

Top left: Clay; one piece, Holy Family, Peru, signed "Merida," 7 inches in height.

Top right: Clay; one piece, Holy Family, ¾ inches in height.

Bottom: Ceramic, low fired; miniature, one piece, ornament, Holy Family, inches in height.

Clay; one piece, Holy Family, Argentina, marked "Artesanias Argentina, Caminito ta Boca," 4 ½ inches in height.

Clay; one piece, Holy Family, includes red rooster symbol of protection, Portugal, 8 inches in height.

Nazare, Portugal.

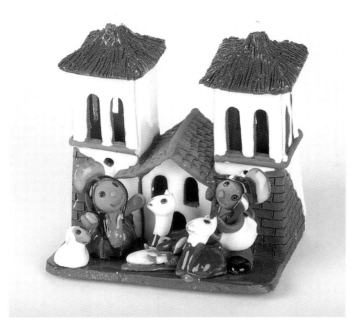

Clay; one piece, Holy Family, mission design, Mexico, 4 ½ inches in height.

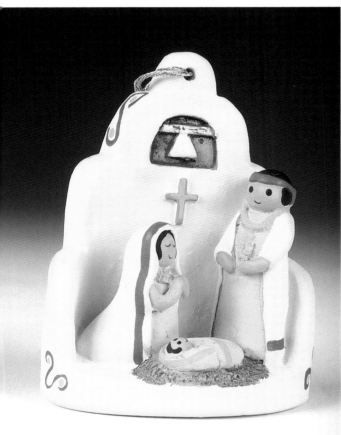

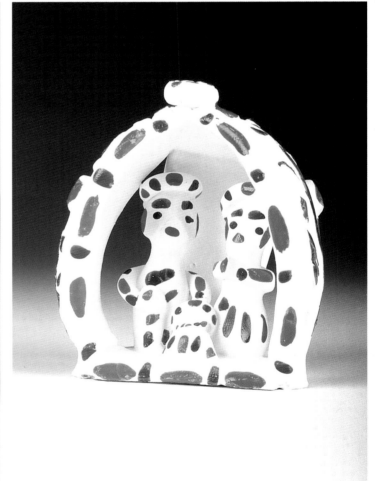

Clay; one piece, ornament, Holy Family, American Indian interpretation, mission design, marked "Teissedre," 3 inches in height.

Clay; one piece, ornament, Holy Family, Argentina, 3 inches in height.

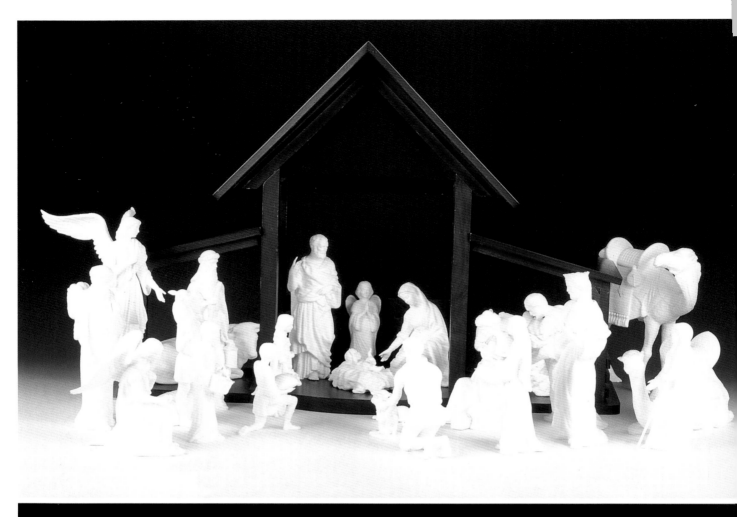

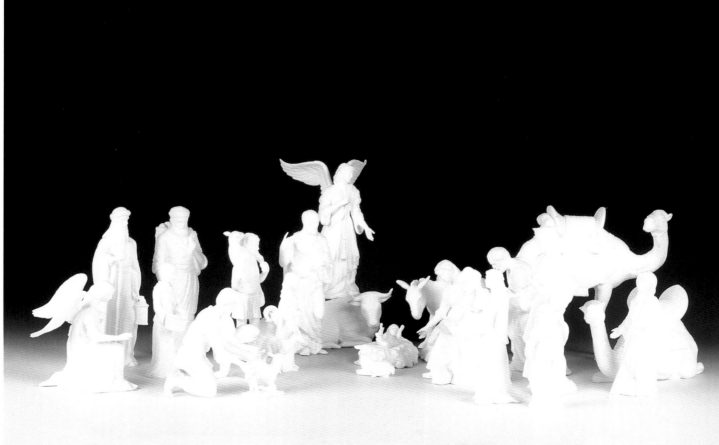

And it came to pass, when the angels had departed from them into the heaven, that the shepherds were saying to one another, "Let us go over to Bethlehem and see this thing that has come to pass, which the Lord has made known to us." So they went with haste, and they found Mary and Joseph, and the babe lying in the manger.

Luke 2: 15, 16

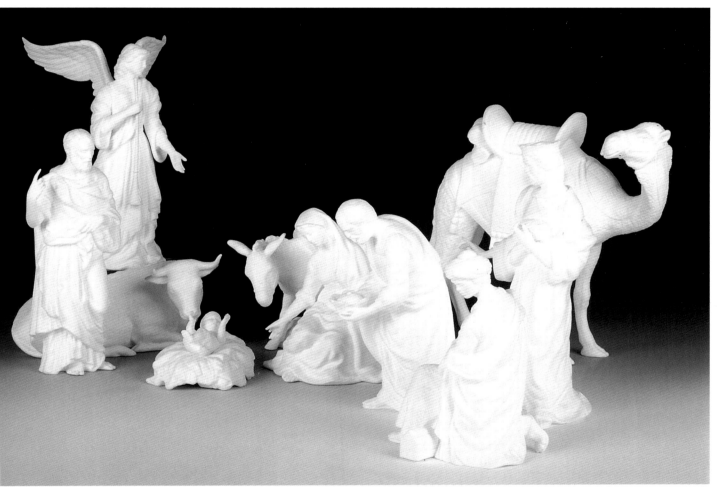

Detail.

Opposite page;
Top: Bone china, wood; twenty-three pieces including angel, kings, shepherds, animals, marked "Lenox 88, fine bone china," tallest figure 8 inches in height.

Bottom: Without manger.

Jaisalmer, India.

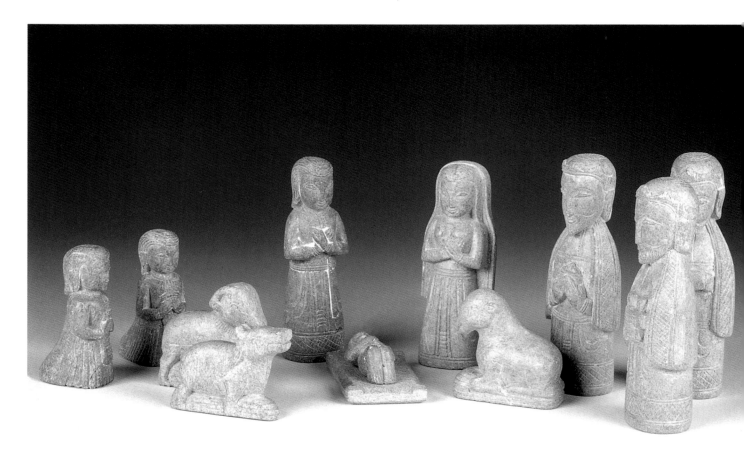

Soap stone, carved; twelve pieces including kings, villagers, and animals, India, 4 inches in height.

Namibia, Africa.

Soap stone, carved; five
pieces, Holy Family with
animals, Africa, 5 ½
inches in height.

33

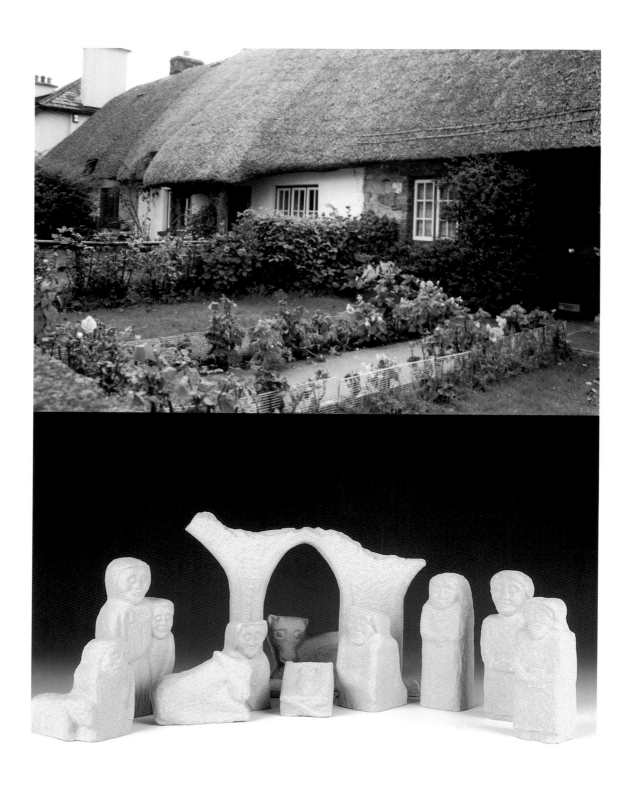

Top: Adare, Ireland.

Bottom: Limestone, cast; eleven pieces including kings, shepherds, and animals, Ireland, Celtic design, original sculpture by Kieran Forde, tallest piece 7 ½ inches in height.

Porcelain, pearl glaze; miniature, eleven pieces including kings and animals, tallest figure 1 ¼ inches in height.

Porcelain, Dresden, gilded; six pieces including animals and Christmas tree that is a functioning bell, Ireland, tallest piece 5 inches in height.

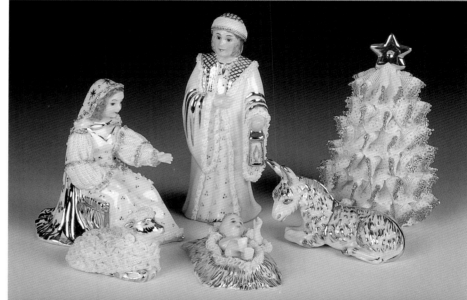

Ceramic; eighteen pieces, including villagers, animals, cactus, and tee-pee, American Indian interpretation, tallest piece 7 ¾ inches in height.

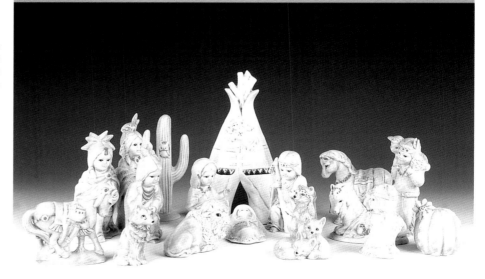

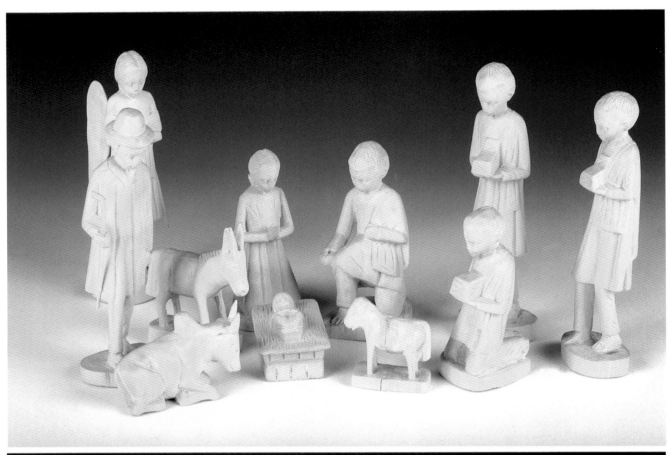

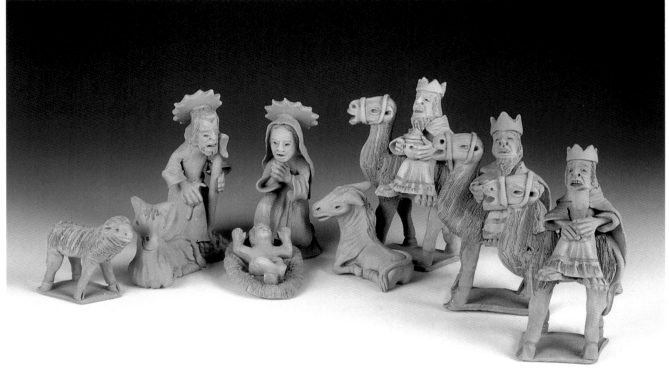

Top: Wood, carved; eleven pieces including angel, villagers, and animals; Ghana, Africa, tallest piece 5 inches in height.

Bottom: Terra-cotta, sculpted; nine pieces including kings and animals, South America, tallest figure 5 ¾ inches in height.

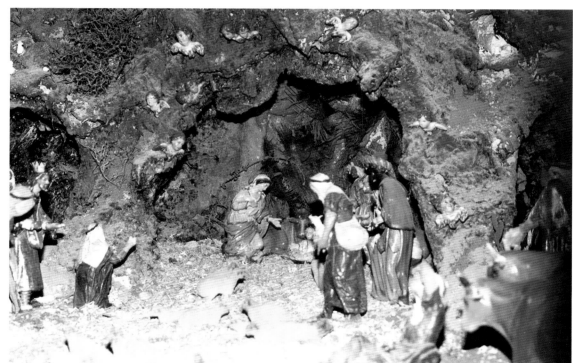

Haifa, Israel.

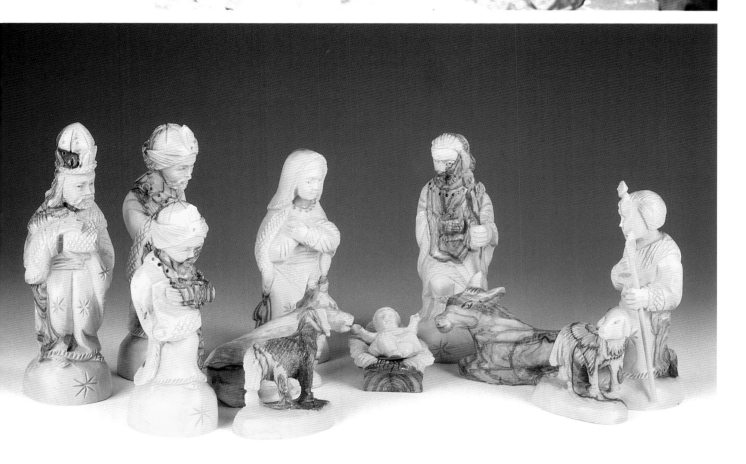

Olive wood, carved; eleven pieces including kings, shepherd, and animals, marked "Made in Israel", tallest figure 6 ½ inches in height.

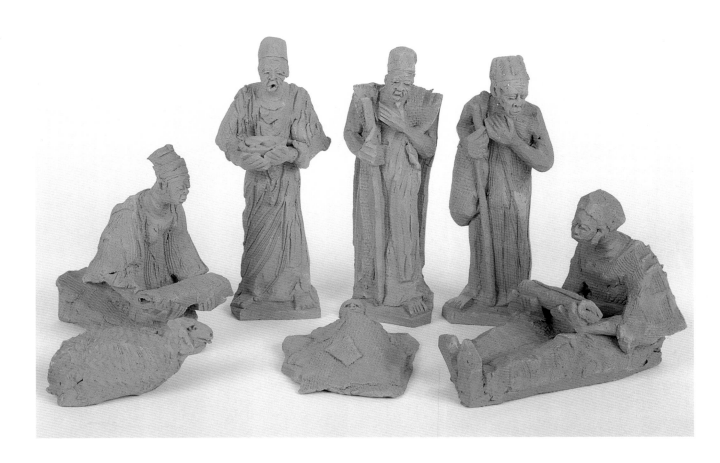

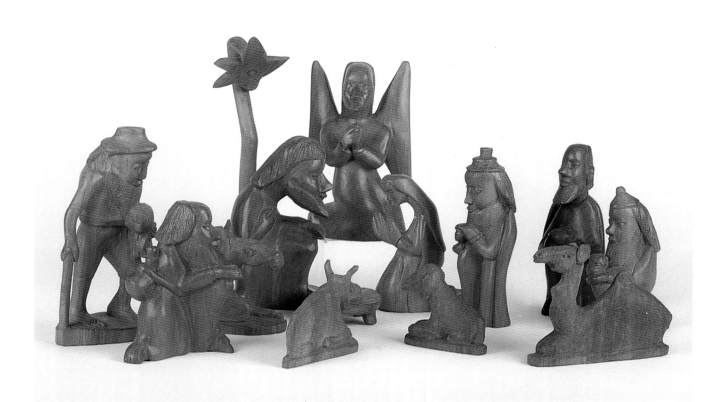

Top: Clay, sculpted; seven pieces including kings and animal, west Africa, marked "Isaacis," tallest figure 6 ¼ inches in height.

Bottom: Wood, carved; fourteen pieces including angel, kings, villagers, animals, and tree; Kenya, Africa, tallest figure 11 ¼ inches in height.

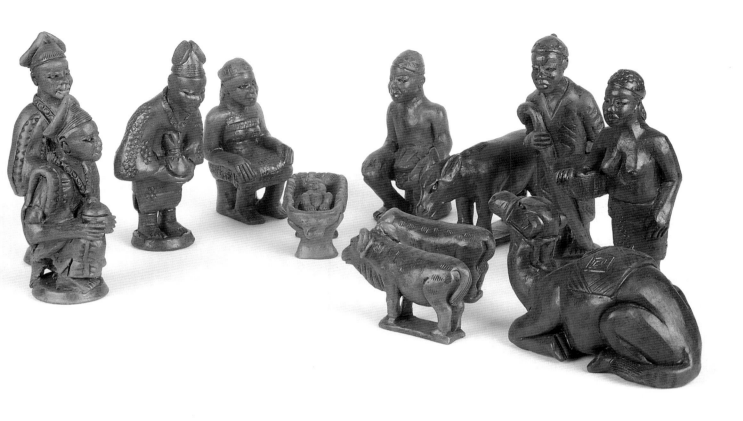

Clay, fired; eleven pieces including kings, shepherds, and animals, African interpretation, Cameroon, tallest piece 7 inches in height.

Cameroon, Africa.

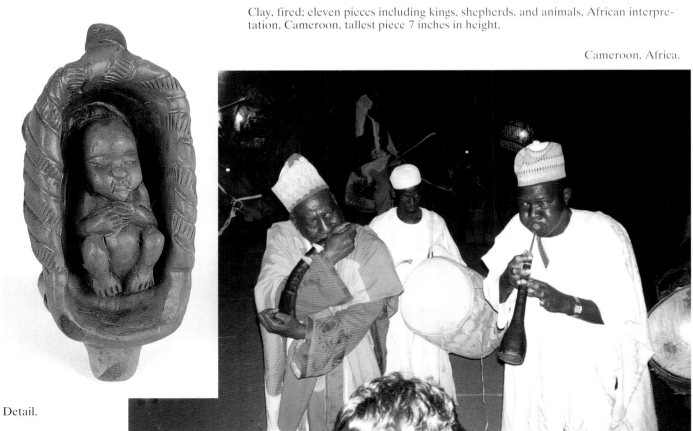

Detail.

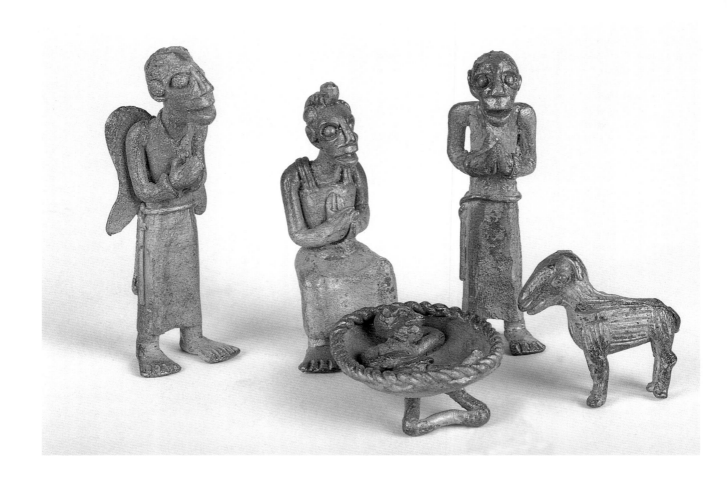

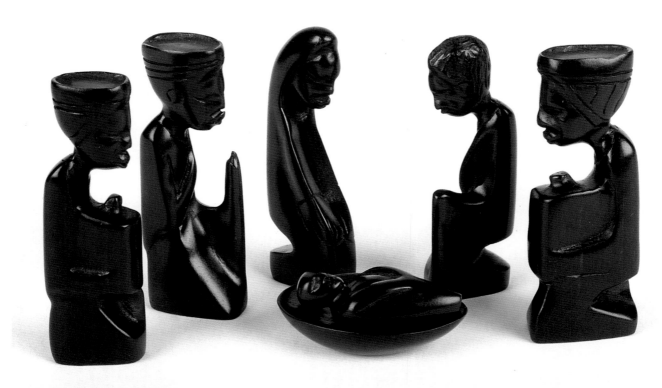

Top: Brass, lost-wax method; five pieces including angel and animal, African interpretation, Cameroon, tallest figure 3 ¼ inches in height.

Bottom: Ebony, carved; seven pieces, including kings, infant Jesus and crib separate pieces, African interpretation, Cameroon, tallest figure 4 inches in height.

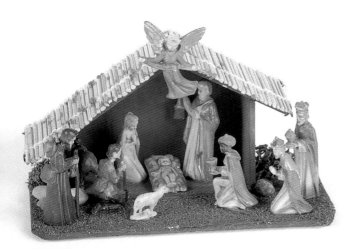

Plastic, wooden manger; one piece with
attached figures, including angel, kings,
shepherds, and animals, 2 ½ inches in
height, c. 1950s.

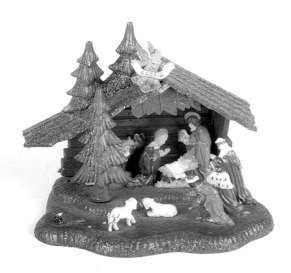

Plastic; one piece, includes angel,
kings, and animals, marked "Made in
Hong Kong," 3 ½ inches in height,
c. 1950s.

Jockey Club, Hong Kong ,
July 1, 1997; celebration of
the return of Hong Kong to
China.

41

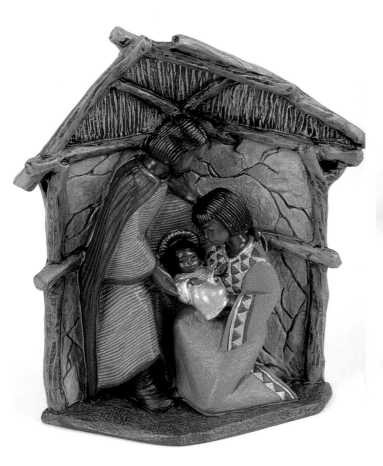

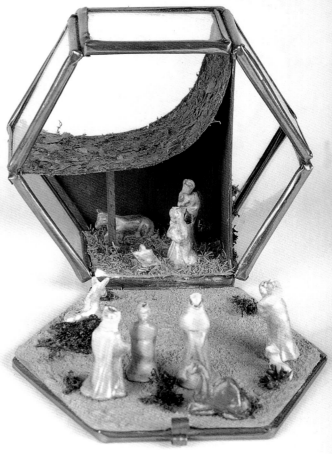

Composite; one piece, marked "Mahogany Miracle, Begotten One, 1999, made in China, Parastone, licensee Enesco Corp.," 7 inches in height.

Plastic, wood; miniature, one piece, figures mounted in glass and brass box, including kings, shepherds, and animals, marked "L. Bigley 1992," figures ¾ inch in height.

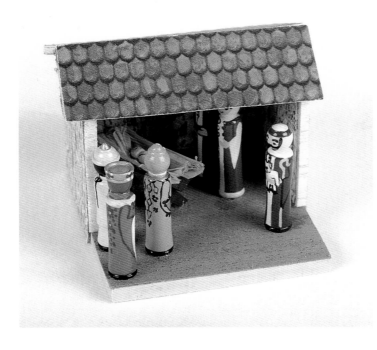

Wood, carved; miniature, one piece, attached figures including kings and shepherd, England, manger 4 inches, tallest figure 1 ¾ inches in height.

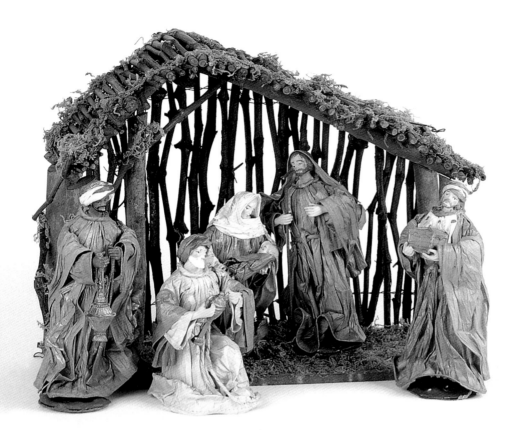

Paper, wood manger; five pieces including kings, marked "Christmas Mornin' made in Taiwan, RSC," tallest figure 8 inches in height.

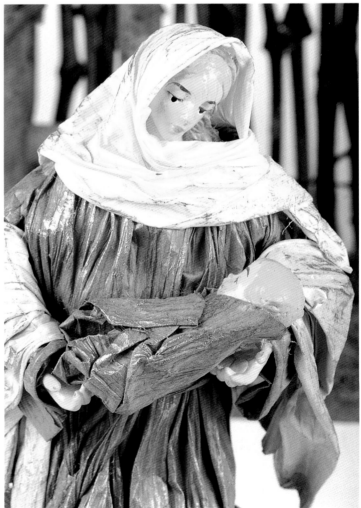

Detail.

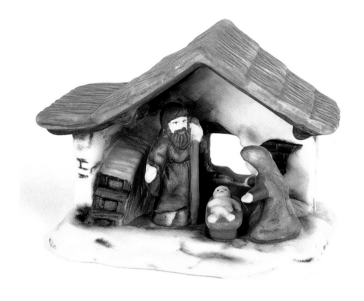

Porcelain; one piece, Holy Family, marked "made in China," 3 ½ inches in height.

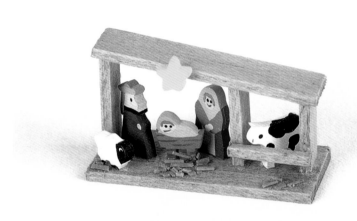

Wood; miniature, one piece, Holy Family, 1 ¾ inches in height.

Paper, wood, dried grasses; miniature, one piece, includes kings and animals, 1 ¼ inches in height.

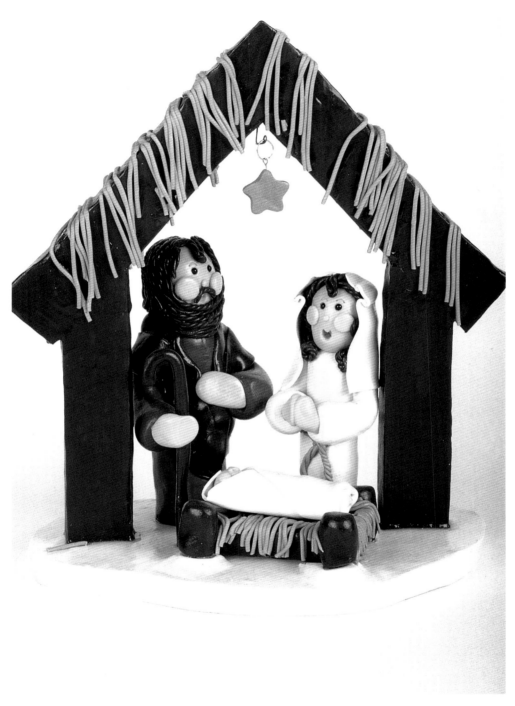

Fimo clay; one piece, Holy Family, marked "Arlene
1995", Pennsylvania, USA, 9 ½ inches in height.

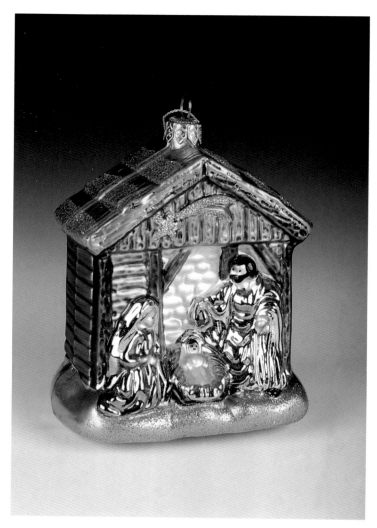

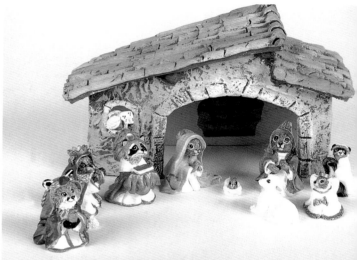

Top left: Glass; ornament, one piece, Holy Family, "Radko" ornament, 5 inches in height.

Bottom left: Composite; hinged display, includes kings and animals, marked "Midwest," 2 ¾ inches in height.

Above: Composition; miniature, ten pieces, forest animals dressed as Holy Family, angel, kings, shepherd and animals, tallest figure 2 inches in height.

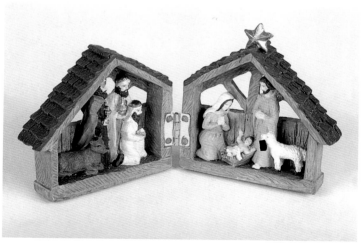

Fabric, soft sculpture; eight pieces including angel and animal, manger 9 inches, tallest figure 4 inches in height.

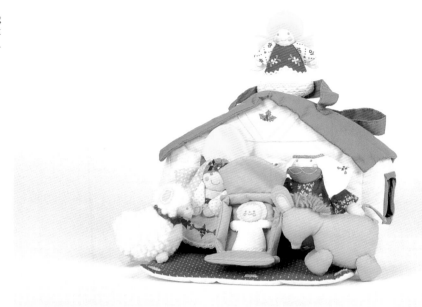

Composite, wood; fifteen pieces including angel, kings, villagers, shepherd, and animals, marked "Fontanini," Italy, tallest figure 12 inches in height. c. 1983.

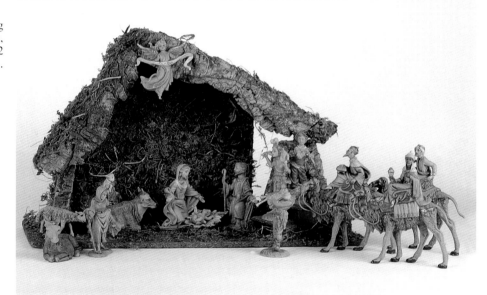

Ceramic; ten pieces including kings, shepherds, and animals, signed "H. G. Healy," tallest figure 3 ½ inches in height.

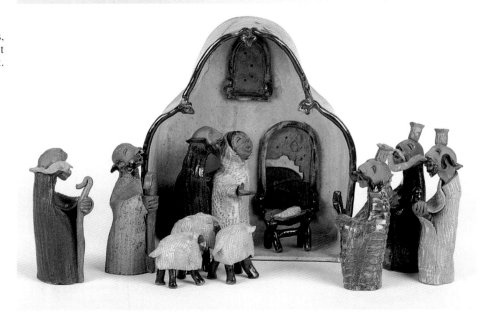

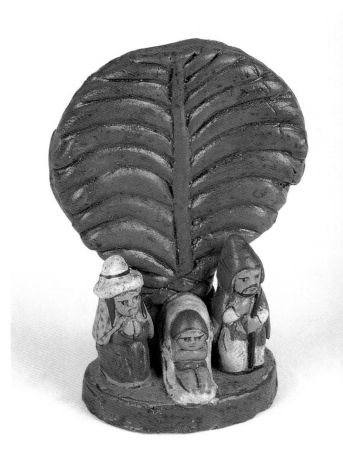

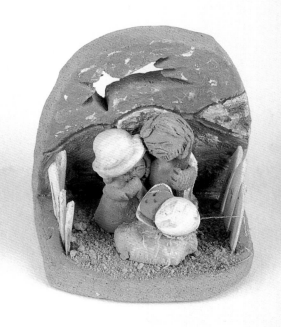

Top left: Clay; one piece, Holy Family, Argentina, 3 inches in height.

Top right: Clay; miniature, one piece, Holy Family, Argentina, ¾ inch in height.

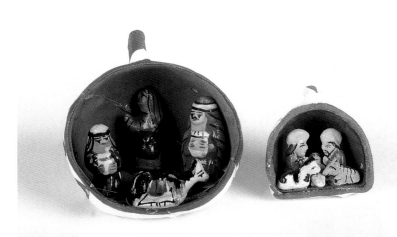

Clay, paper; miniature, one piece, Argentina, Holy Family ¾ inch, three kings and camel 1 ½ inches in height.

Falkland Islands (near the southern tip of South America).

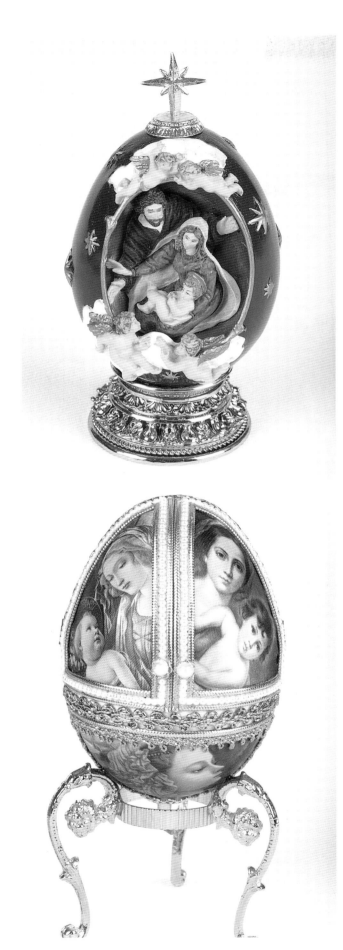

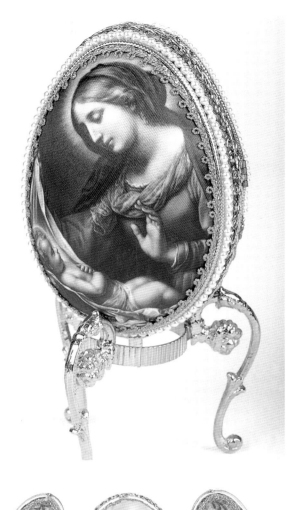

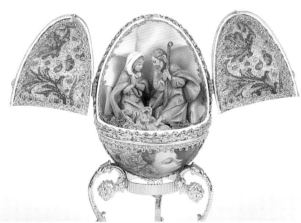

Top left: Porcelain, resin, 24k gold; egg, marked "Limited Edition, House of Faberge, The Franklin Mint, made in China," 4 ¼ inches in height.

Top right: Egg, fabric (printed silk), decorative cording, pearls, brass; hinged "doors" open to show Fontannini Nativity scene, music box, Italy, 6 inches in height.

Bottom left: Detail, reverse side.

Bottom right: Detail, open.

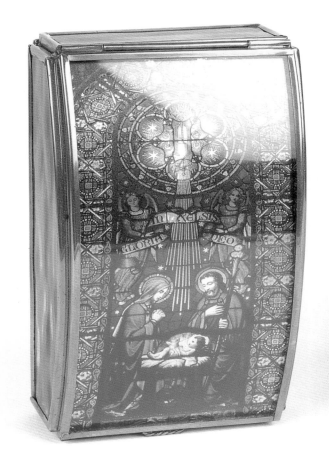

Glass, 24k gold-plated brass, mirrored bottom; box, 5 ¼ inches in height.

Glass, pewter; plate, 7 inches in diameter.

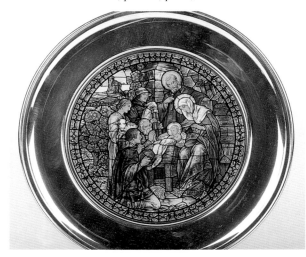

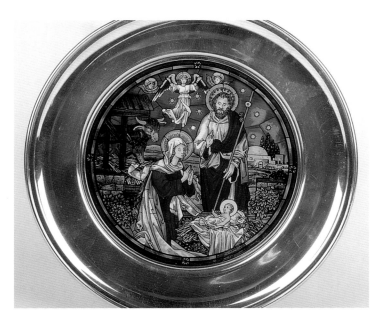

Glass, pewter; plate, 7 inches in diameter.

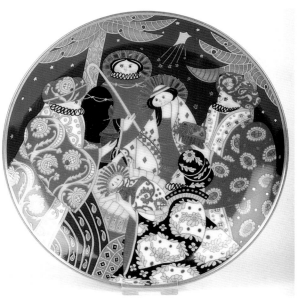

Porcelain; plate, marked "House of Faberge, The Nativity '96, Limited Edition," 8 inches in diameter.

50

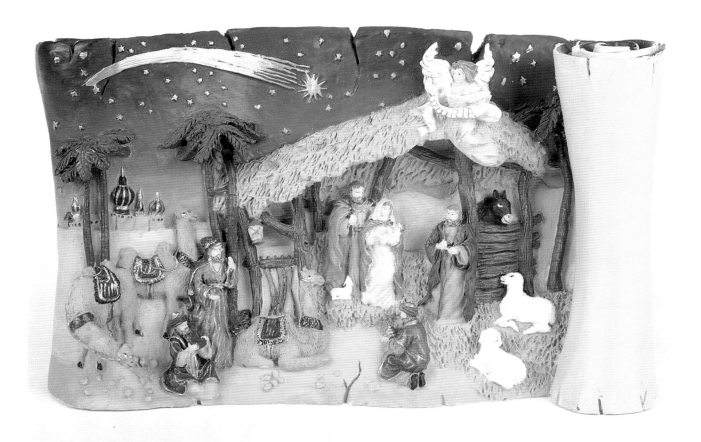

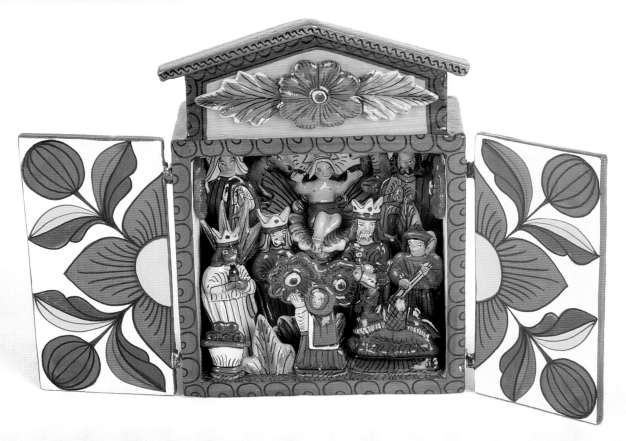

Top: Resin, molded; one piece, includes angel, kings, shepherd, animals, Bethlehem in the background, designed as a "scroll," marked "Roman, Inc., Made in China," 8 ½ inches wide, 5 inches in height.

Bottom: Wood, clay; one piece, includes kings, villager playing a musical instrument, South American, 5 ¾ inches in height.

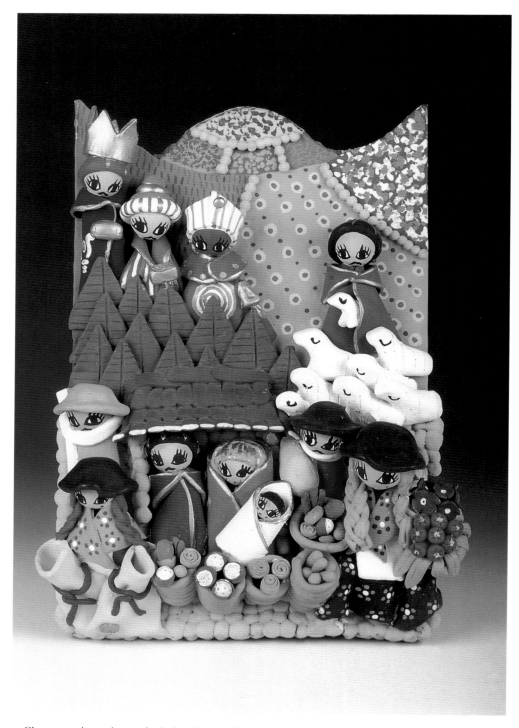

Clay; one piece plaque, includes kings, villagers, and animals, Venezuela, 12 inches in height.

Composite; one piece, snow-people as Holy Family, 4 inches in height.

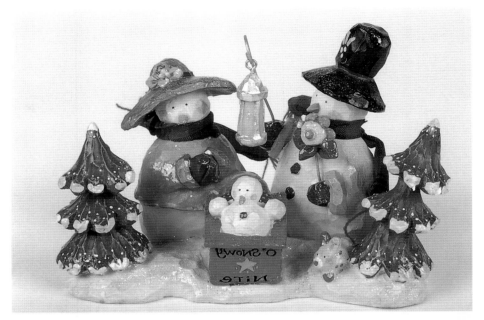

Clay; one piece, includes angel, infant Jesus, and animal, Argentina, 3 ¼ inches in height.

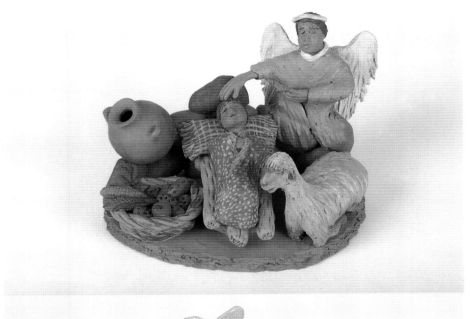

Ceramic; one piece, Holy Family, Venezuela, 5 inches wide, 2 ½ inches in height.

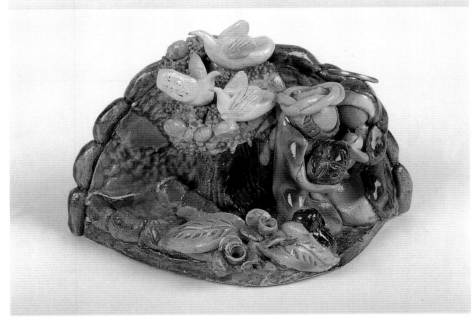

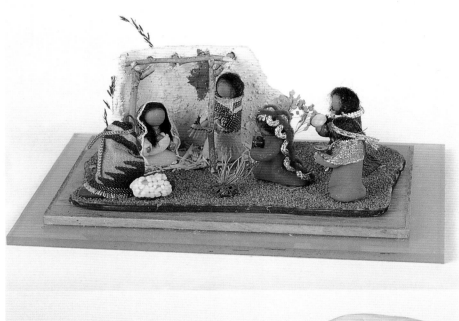

Clay, wood, fabric, dried grasses; one piece, includes kings and animal, Mexico, 3 inches in height.

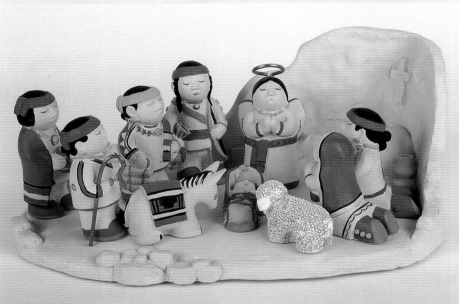

Clay; ten pieces, American Indian Pueblo interpretation, signed "Teissedre 86-A/86 MW," 12 ½ inches wide, 6 inches in height.

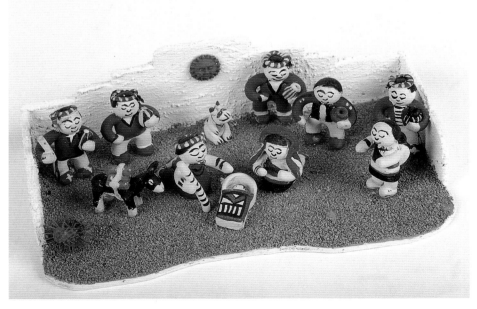

Clay; miniature, one piece American Indian and South West interpretation, includes kings, villagers, and animals, signed "Bogg," ½ inch in height.

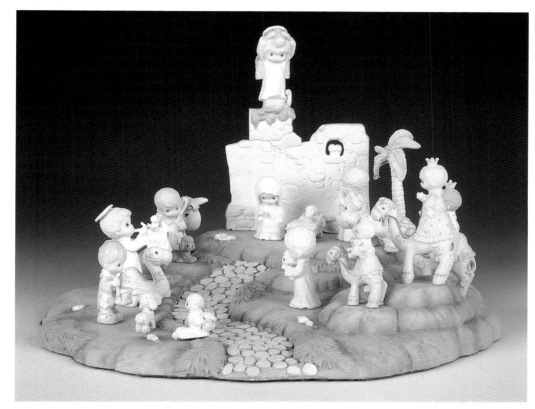

Ceramic, painted pewter; twenty pieces including children as angels, kings, villagers, marked "Precious Moments," tallest figure 2 ½ inches in height.

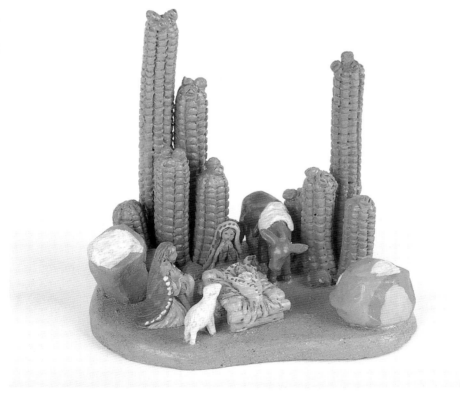

Clay; one piece, Holy Family, Argentina, signed "Jujuy, 1998," inches in height.

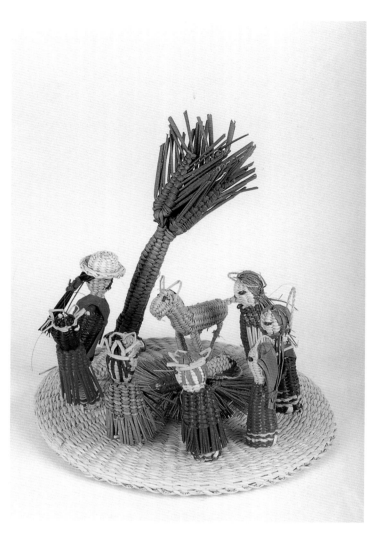

Straw, woven; one piece, includes angel, kings, and animals, Equator, marked "Cruz Importers," 4 ¾ inches in height.

The wolf shall dwell with the lamb: and the leopard shall lie down with the kid: the calf and the lion, and the sheep shall abide together, and a little child shall lead them.

Isaiah 11: 6

Sand-cast; seven pieces, animals with infant Jesus, marked "Babes of Bethlehem, USA," tallest piece 6 inches in height.

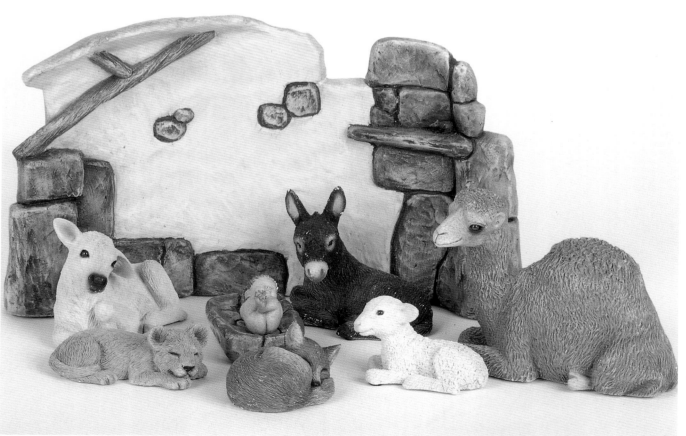

Gardens of Giverney, France.

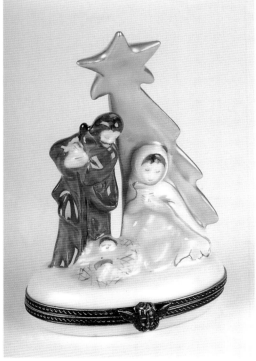

...elain; one piece
...x, Holy Family,
...rked "Limoges,
...ce," 4 inches in
height.

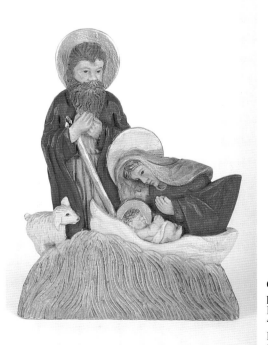

Composite; one
piece plaque, Holy
Family, marked
"Midwest, made in
Philippines," 9 ¼
inches in height.

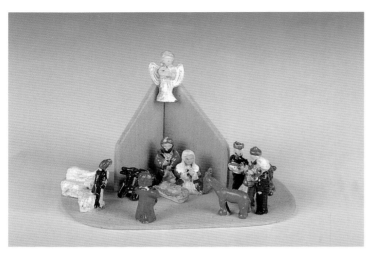

Lead, wood; miniature, one piece with thirteen figures including angel, kings, shepherd, and animals, tallest figure 2 inches in height.

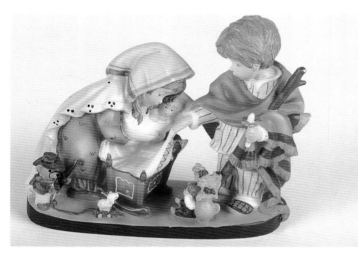

Resin; one piece, children as Holy Family with toys, marked "Original Lisi Martin, by Dolfi," 3 ½ inches in height.

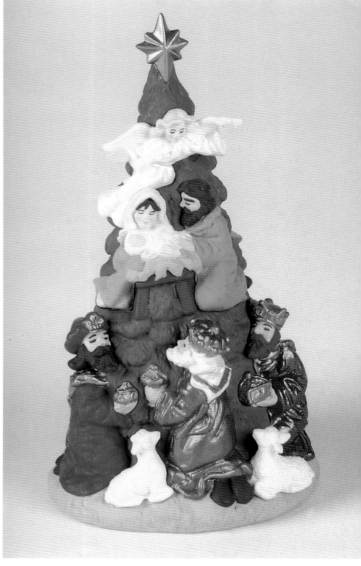

Ceramic; one piece, Christmas tree with Holy Family, angel, kings, and animals, marked "Hallmark," 4 inches in height.

Opposite page:
Top: Porcelain, 24k gold accents, wood; twelve pieces including kings, shepherds, and animals, marked "The House of Faberge, The Nativity, Franklin Mint," tallest figure 5 inches in height.

Bottom: Detail.

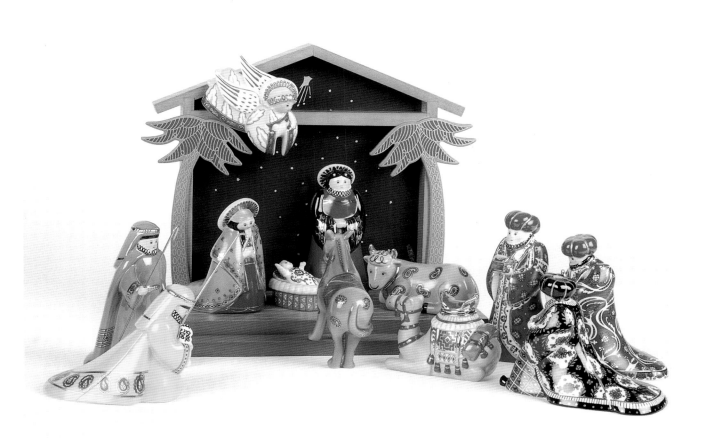

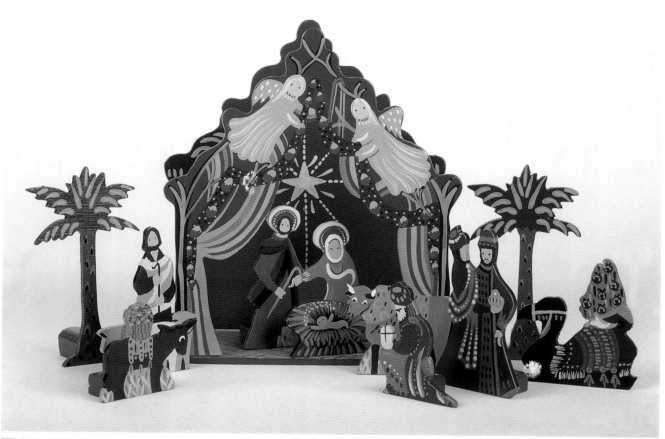

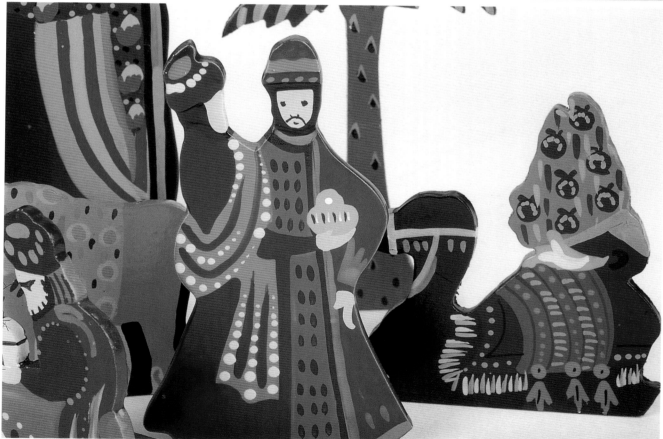

Top: Wood; twelve pieces including kings, shepherd, and animals, marked "Made in Sri Lanka, VBI Inc.," tallest figure 4 ½ inches in height.

Bottom: Detail.

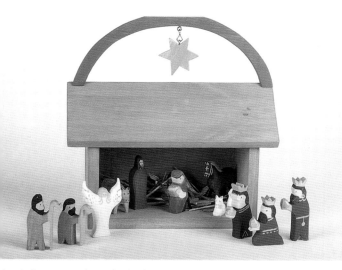

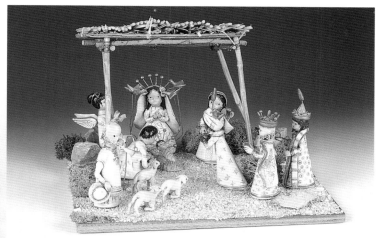

Wood; fourteen pieces including angel, kings, shepherds, animals, star, Sweden, 5 ¾ inches, tallest figure 2 ½ inches in height.

Ceramic; fifteen pieces including angel, kings, shepherds, and animals, Mexico; displayed on manger of wood, straw; crushed coral base was hand made by Cathy Lincoln, tallest figure 3 ½ inches in height.

Acapulco, Mexico.

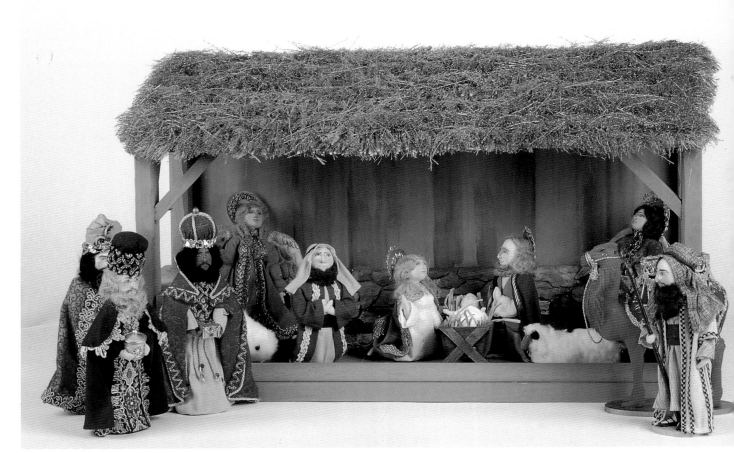

Fabric; thirteen pieces including angel, kings, shepherds, and animals, signed "Gladys Boalt," marked "Made exclusively for The Gazebo Store, NYC" 22 inches wide, 13 ½ inches in height.

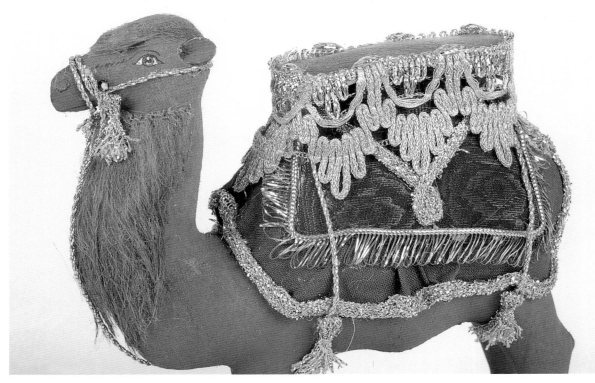

Detail.

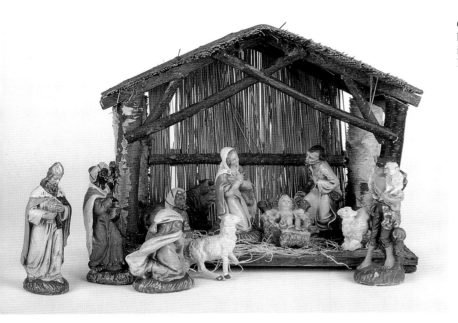

Composite, twig manger; ten pieces including kings, shepherds, and animals, tallest figure 6 ½ inches in height. Grandmother Lincoln's Nativity, c. 1935.

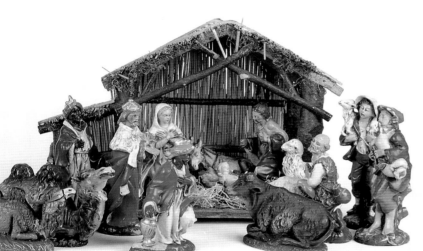

Composite, twig manger; sixteen pieces including kings, shepherds, and animals, Italy, 8 ½ inches in height. Emma Lincoln's first Nativity, c. 1955.

Saint Peter's Basilica, Rome, Italy.

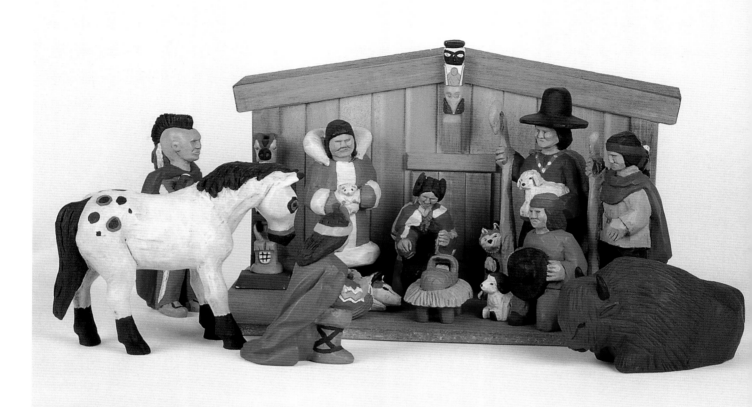

Ceramic, wood; ten pieces, American Indian interpretation, including chief (king) offering turkey, shepherd, and animals, marked "Nova 5 Inc., Albuquerque, New Mexico, 1994," 10 ½ inches in height.

Detail.

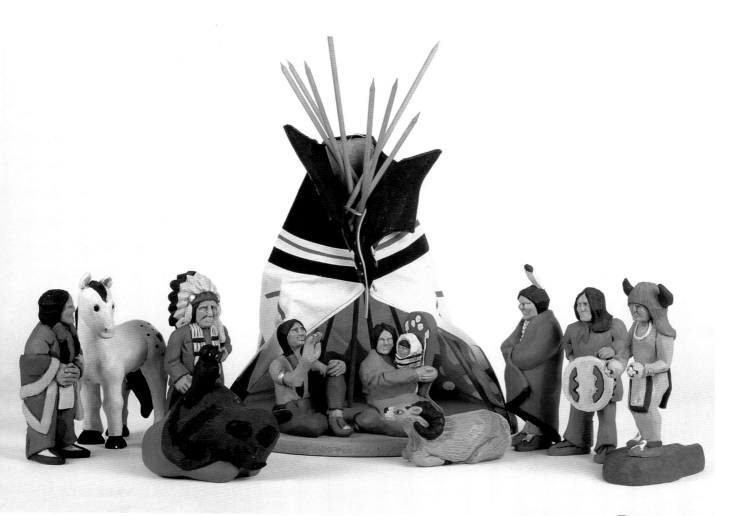

eramic, fabric; ten pieces, American Indian interpretation, ncluding tee-pee manger, chief (king), villagers with musical nstruments, and animals, marked "Nova 5 Inc., Albuquerque, ew Mexico," tee-pee 18 inches, tallest figure 8 inches in height.

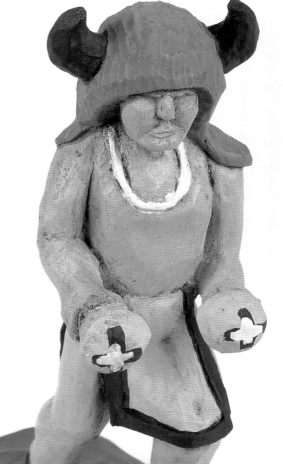

Detail.

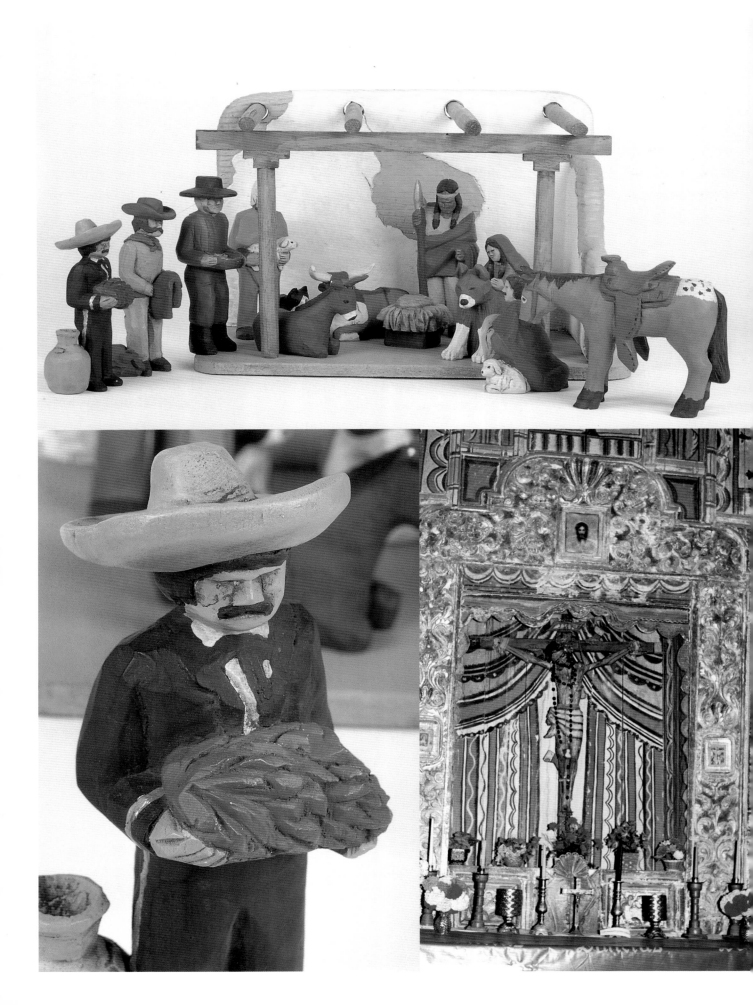

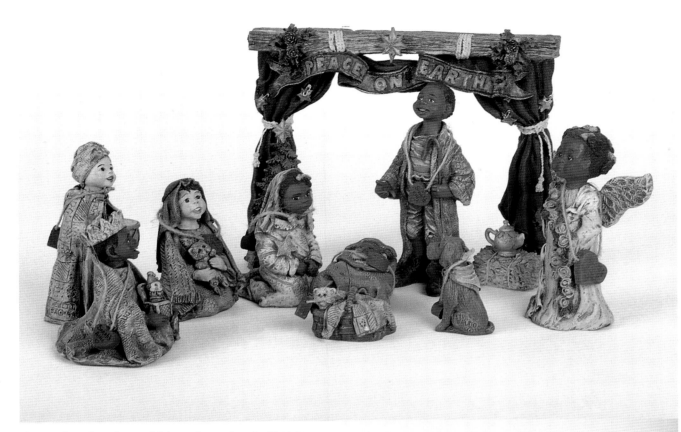

Composite; nine pieces, children play-acting the Nativity,
marked "Sarah's Attic, Limited Edition, 'Back Stage'-
Boyd's Bears & Friends, Nativity Series, made in China,"
6 inches in height.

Detail.

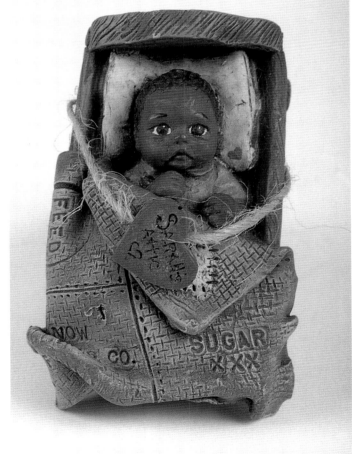

Opposite page;
Top: Ceramic ("hydrastone"), wood; eleven
pieces, Southwest tri-cultural interpreta-
tion: cowboy-Mexican-American Indian;
includes "villagers" offering gifts of lamb,
corn, saddle, red peppers, marked "Nova 5
Inc., Albuquerque, New Mexico," 7 ½
inches in height.

Bottom left: Detail.

Bottom right: El Santuario de Chimayo,
New Mexico.

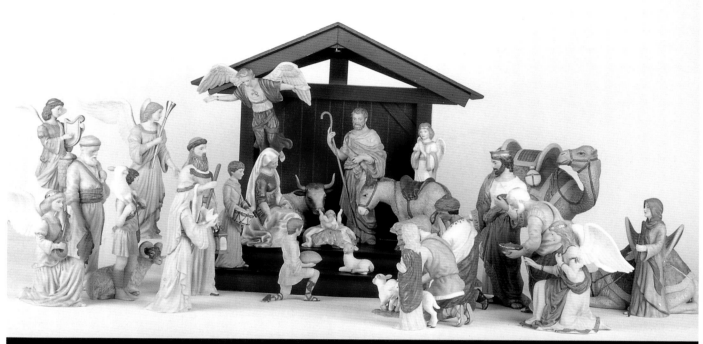

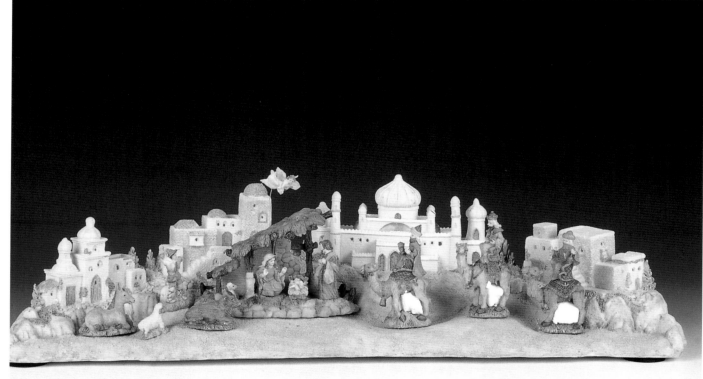

Opposite page;

Top: Bisque porcelain, wood; twenty-four pieces including angels, kings, shepherds, animals, marked "Lenox, The Renaissance Nativity Collection," tallest figure 12 inches in height.

Bottom: Resin, cast; one piece, musical lamp, marked "Little Town of Bethlehem," manger and figures attached including angel, kings, shepherds, and animals, 9 inches wide, 5 inches in height.

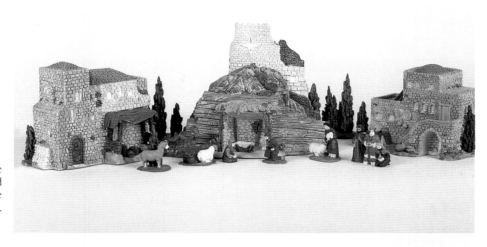

Composite; twelve pieces including village buildings, kings, shepherds, animals, marked "Dept. 56 Nativity Scene," tallest figure 4 inches in height.

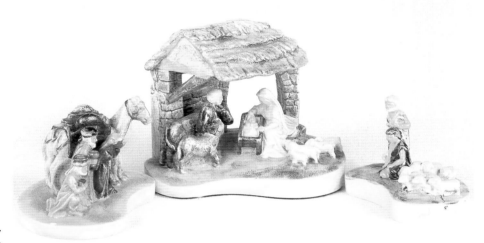

Ceramic; three pieces including manger, kings, shepherds, marked "Sebastian, Hudson, Massachusetts," 3 inches in height.

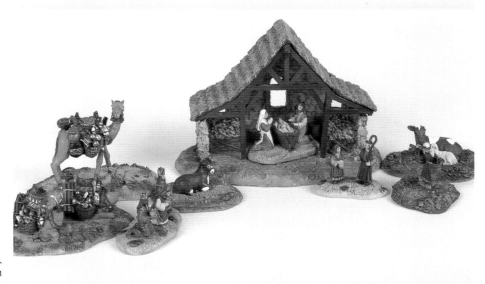

Composite; eight pieces including kings, shepherds, and animals, marked "Hawthorn Miniature Nativity, 1995," 3 ½ inches in height.

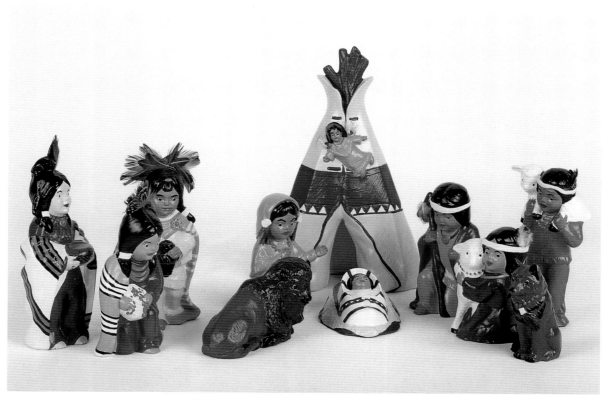

Ceramic, feathers; eleven pieces including tee-pee, American
Indian interpretation, buffalo and wolf, 7 ¾ inches in height.

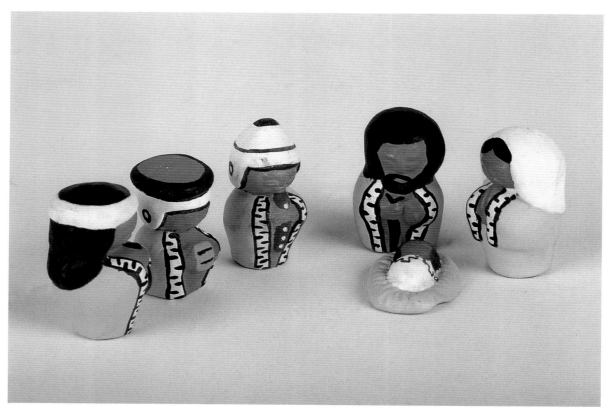

Clay; miniature, six pieces including kings, Peru, 1 ¾ inches in height.

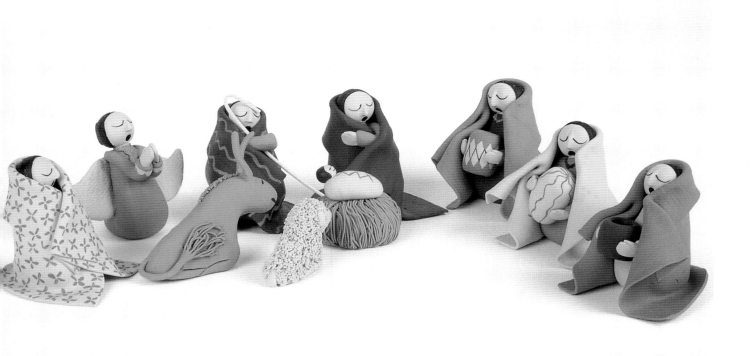

Clay: ten pieces including angel, kings, shepherd, villager, and animals, Pueblo Indian "story teller" interpretation, signed "Jodi Jones," 2 ¾ inches in height.

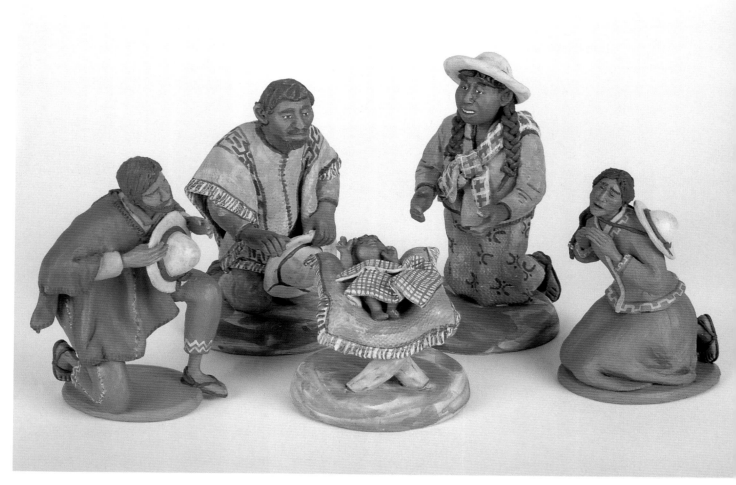

Clay; five pieces including villagers, Mexico, marked "Hermos. Mario y Miguel Meneloza-Jopey," 5 ¾ inches in height.

Clay; miniature, seven pieces including sheep, and cow, "mud dolls" from Spain, 1 ½ inches in height.

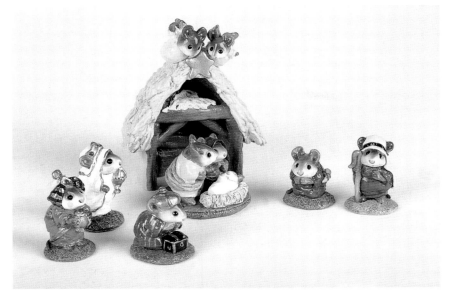

Ceramic; seven pieces, mice in Nativity costume, signed "Annette Peterson, Wee Forest Folk, 1987," tallest figure 3 ½ inches in height.

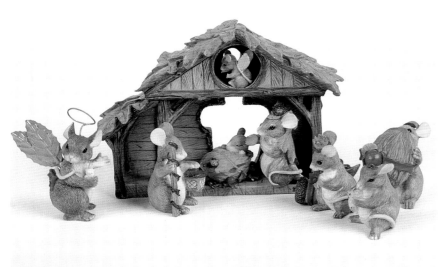

Ceramic, cast; seven pieces, mice in Nativity costume, marked "Squashville Village, The Christmas Pageant, from original sculptures by Dean Griff," tallest figure 5 inches in height.

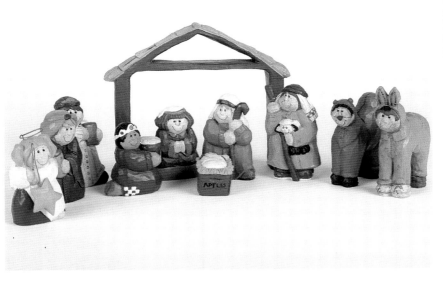

Composite; ten pieces, children play-acting Nativity scene, including animal costume, tallest figure 5 inches in height.

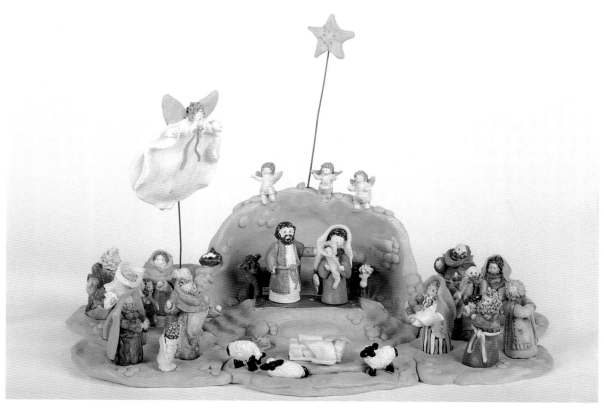

Clay, sculptured; three pieces, mounted with thirty figures including angels, kings, shepherds, villagers, and animals, marked "Overly-Raker, Inc. 1996," 13 inches wide, 8 inches in height.

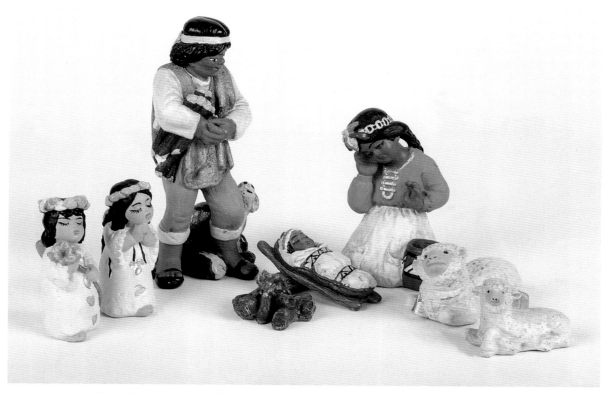

Clay; eight pieces, American Indian interpretation, tallest figure 7 inches in height.

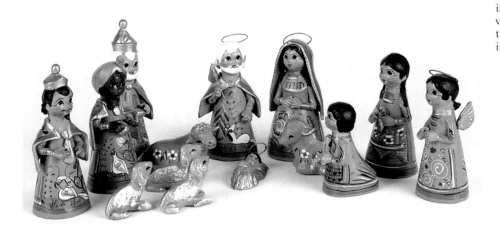

Clay; fourteen pieces including angel, kings, villagers, and animals, tallest figure 4 ½ inches in height.

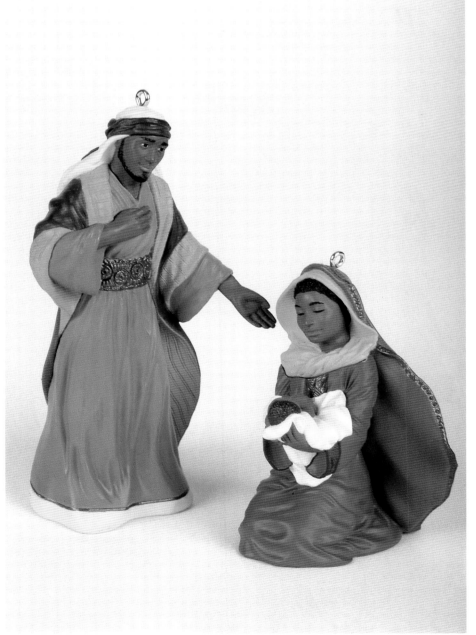

Composite; two ornaments, Holy Family, marked "Hallmark 95," 4 ½ inches in height.

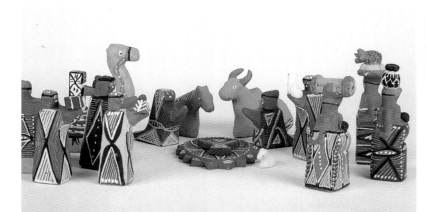

Clay; fifteen pieces including kings, shepherd, villagers, and animals, Africa, tallest figure 4 ¾ inches in height.

Detail.

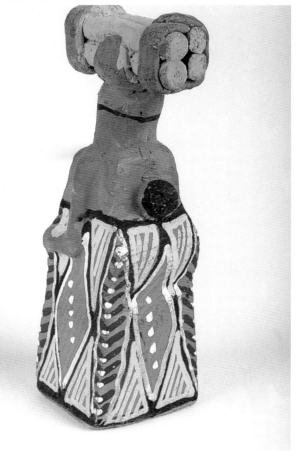

Detail.

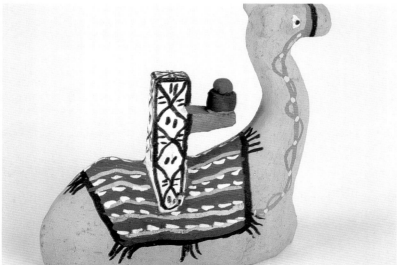

Detail.

76

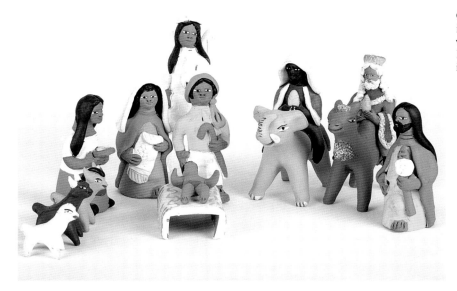

Clay; twelve pieces including angel, kings, villagers, and animals, Mexico, tallest figure 5 ½ inches in height.

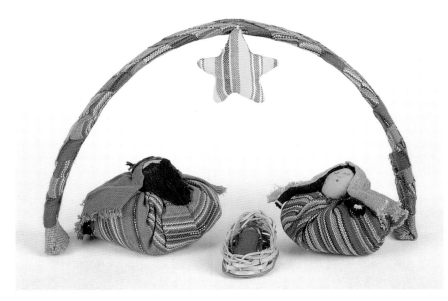

Fabric; four pieces including rainbow arch with star, South America, tallest piece 5 ½ inches in height.

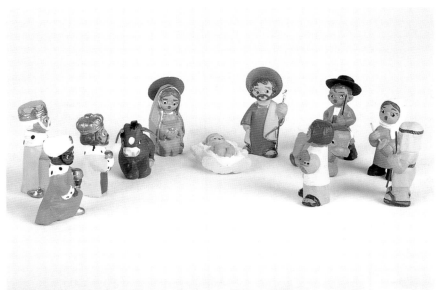

Clay, paper; miniature, twelve pieces including kings, shepherd, villagers, and animals, "mud dolls" from Spain, 2 inches in height.

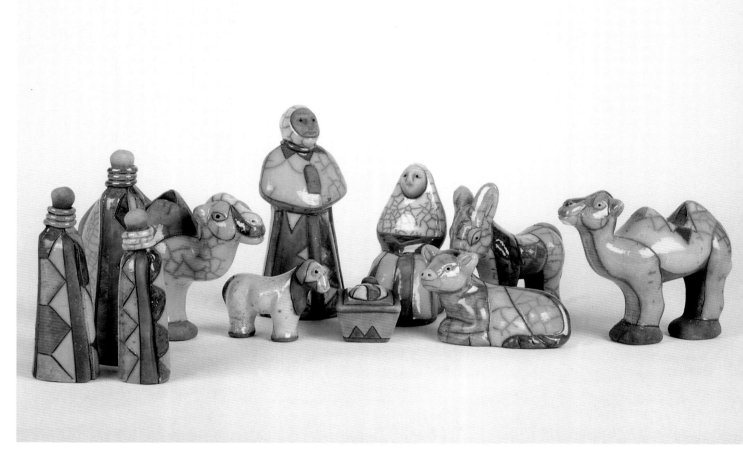

Clay; eleven pieces including kings, shepherd, and animals, "raku" pottery from South Africa made by the Ndebele tribe, marked "African Express, Inc. 1995, made in South Africa." (The clay figures are baked in a kiln for twelve hours, glazed. Then utilizing an ancient Japanese technique called "raku firing," they are placed in a gas kiln and fired to 950 degrees centigrade. To complete the process the figures are place in a bed of smoldering sawdust to create a unique pattern on the glaze.) Tallest figure 7 inches in height.

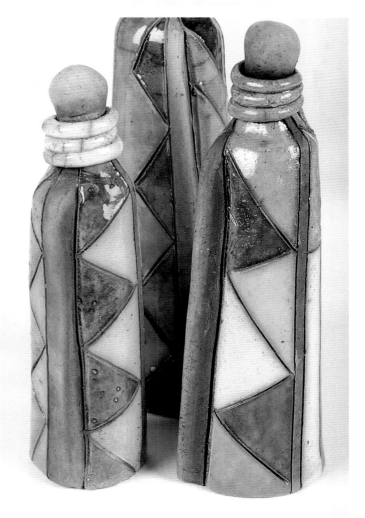

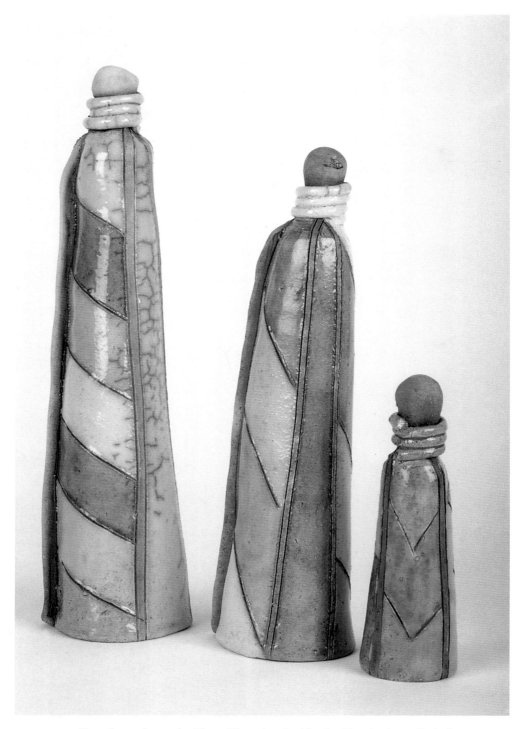

Clay; three pieces, the Three Kings, inspired by the Masai culture, "raku"
pottery from South Africa, Botswana, tallest figure 13 inches in height.

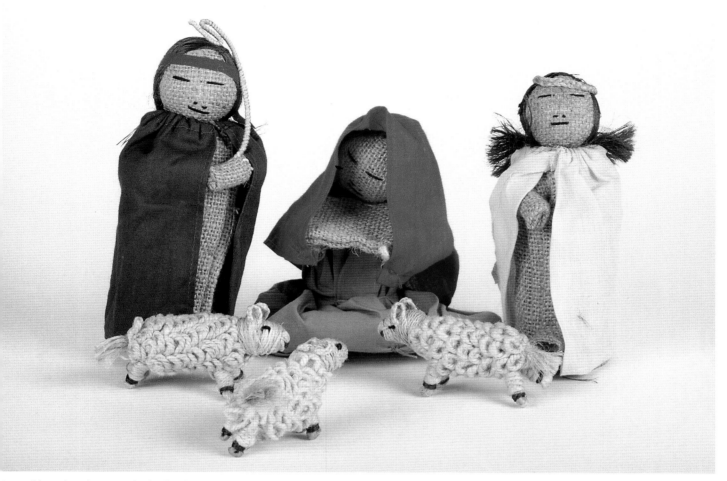

Natural jute, hand woven cloth; six pieces including angel and sheep, Bangladesh, tallest figure 6 ½ inches in height.

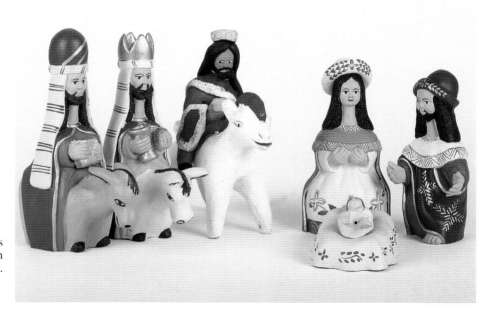

Ceramic, low fired; seven pieces including kings and animals, Peru, tallest figure 6 inches in height.

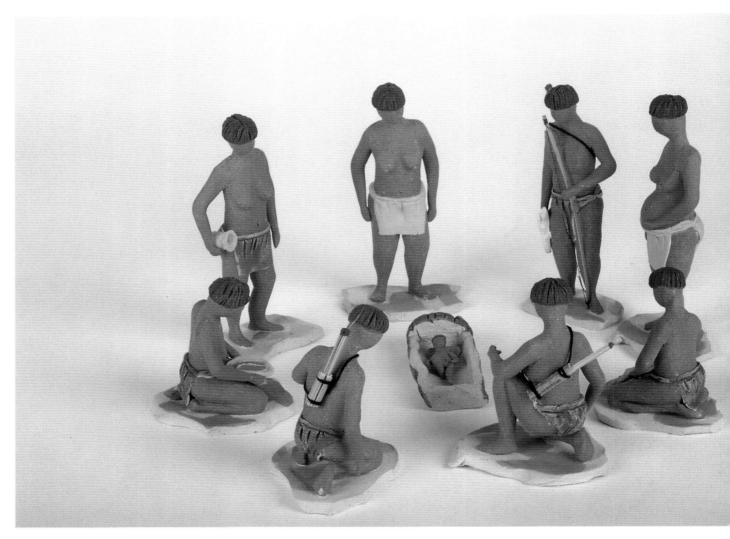

Clay; ten pieces including villagers, one expectant mother, Amazon Indian interpretation, Venezuela, 4 ¾ inches in height.

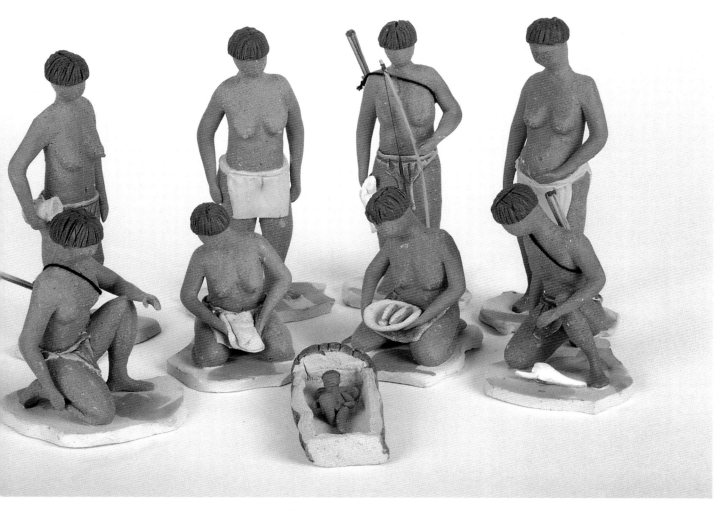

Showing fronts.

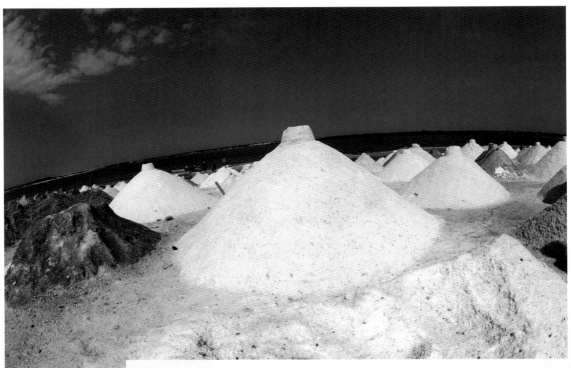

The salt beds of Rose Lake, Senegal, West Africa.

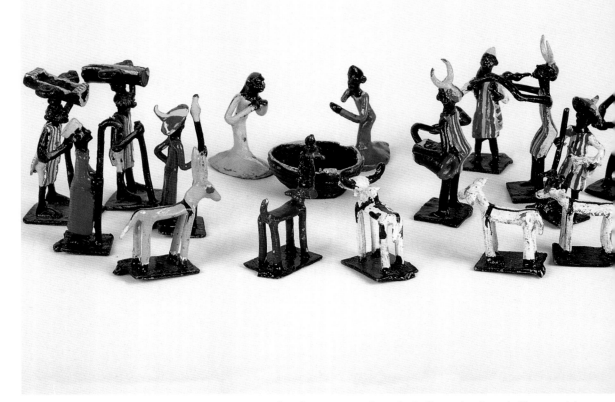

Lead; seventeen pieces including animals and villagers with musical instruments and carrying goods, made from weights used to measure bulk commodities, African interpretation, Senegal, West Africa, 3 inches in height.

84

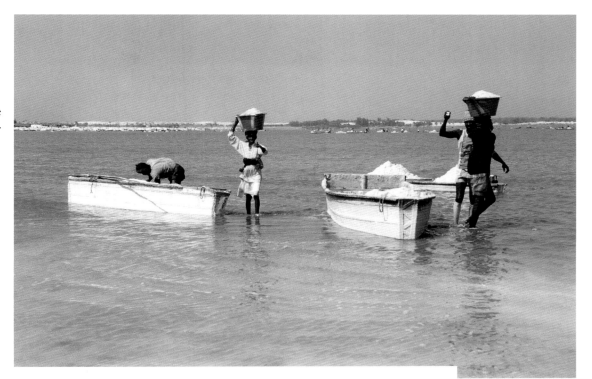

Harvesting the salt, Rose Lake, Senegal, West Africa.

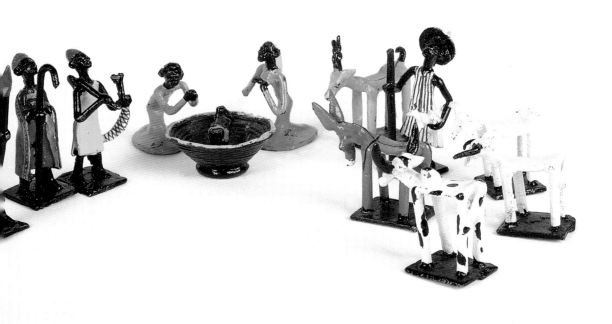

Lead; thirteen pieces including kings, shepherds, and animals, made from weights used to measure bulk produce, African interpretation, Senegal, West Africa, 3 inches in height.

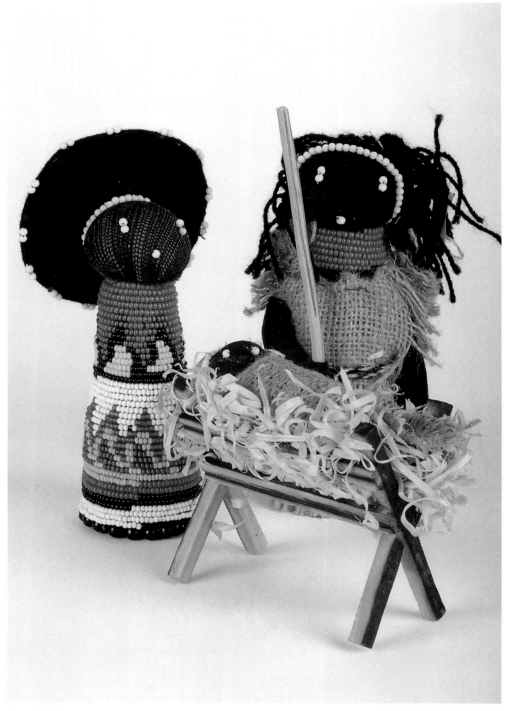

Fabric, beads, wood, straw;
three pieces, Holy Family,
Zulu interpretation, Africa,
from the self-help group
Kwa Zigi Gimi, 3 inches in
height.

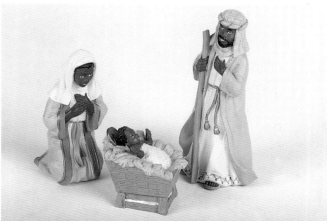

Composite; three pieces,
Holy Family, 4 ½ inches in
height.

Oberammergau, Germany.

Clay, fabric, wood, metal; seven pieces in 16th century theme, includes king and assistant carrying gifts of "silver" and copper, Germany, tallest figure 8 ½ inches in height.

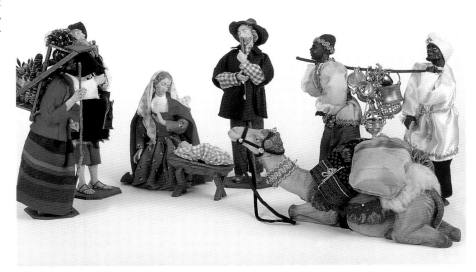

Detail.

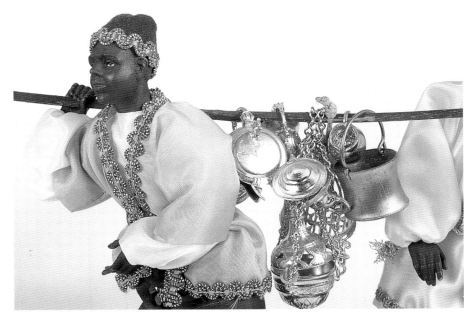

87

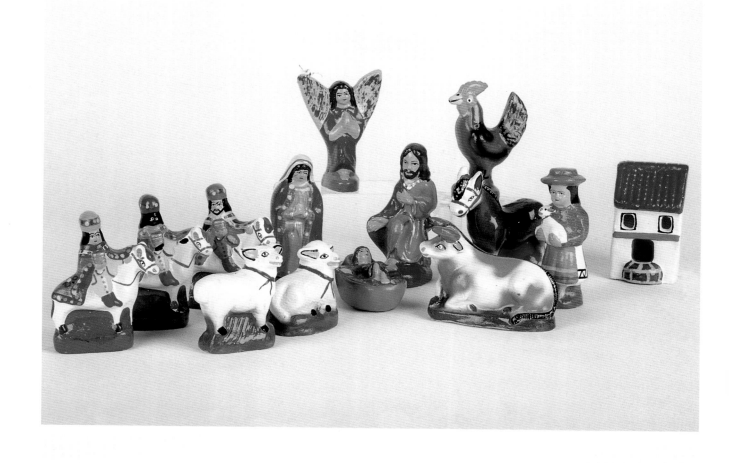

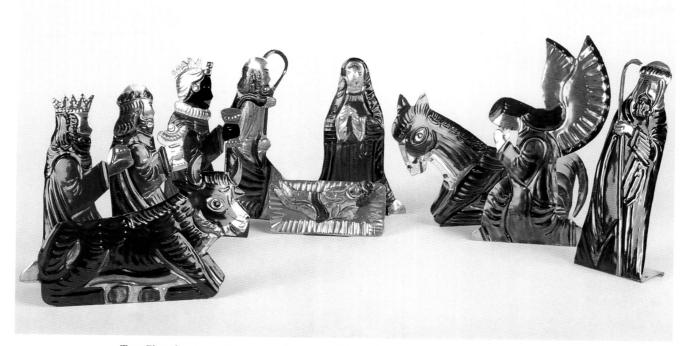

Top: Clay; fourteen pieces including angel, kings, villager, house, animals, rooster, which is the symbol of protection, made in Pujili, Ecuador, tallest figure 4 inches in height.

Bottom: Tin, pressed; nine pieces including angel, kings, shepherd, and animals, Mexico, tallest figure 6 ½ inches in height.

Now when Jesus was born in Bethlehem of Judea…behold, Magi came from the East to Jerusalem, saying, "Where is he that is born king of the Jews? For we have seen his star in the East and have come to worship him."

Matthew 2: 1, 2

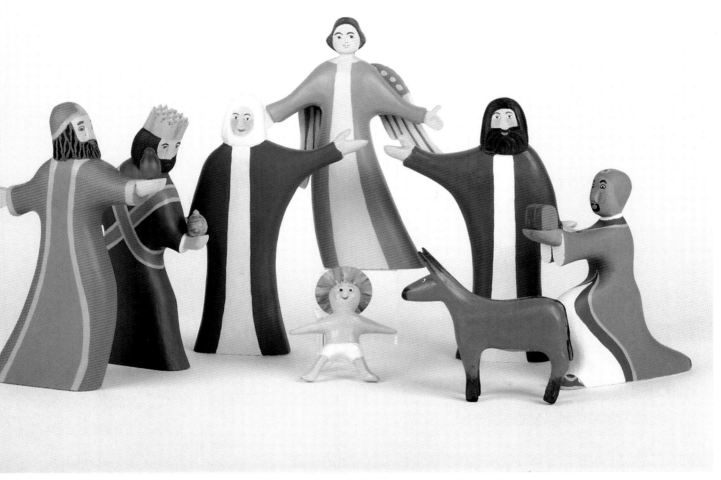

Wood, carved; eight pieces including angel, kings, and animals, marked "CRc A&J," tallest figure 10 inches in height.

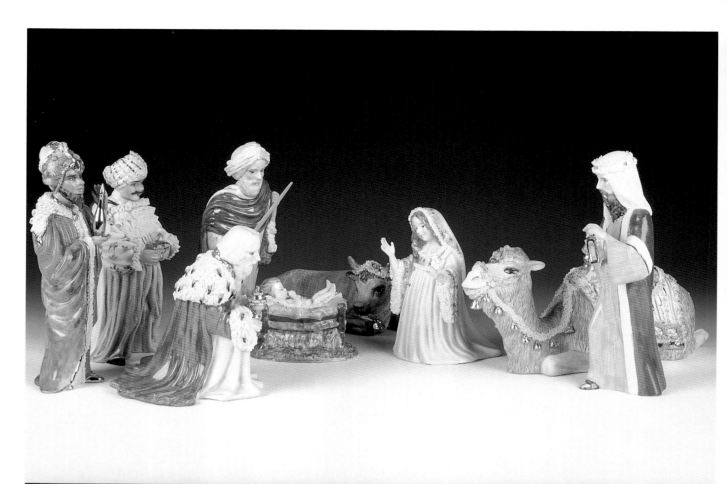

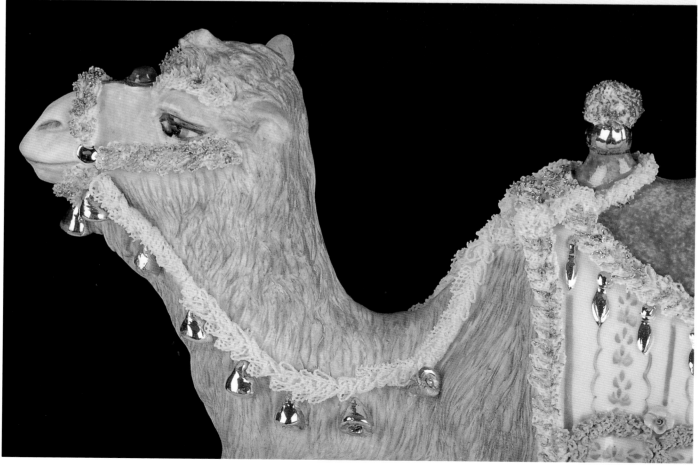

90

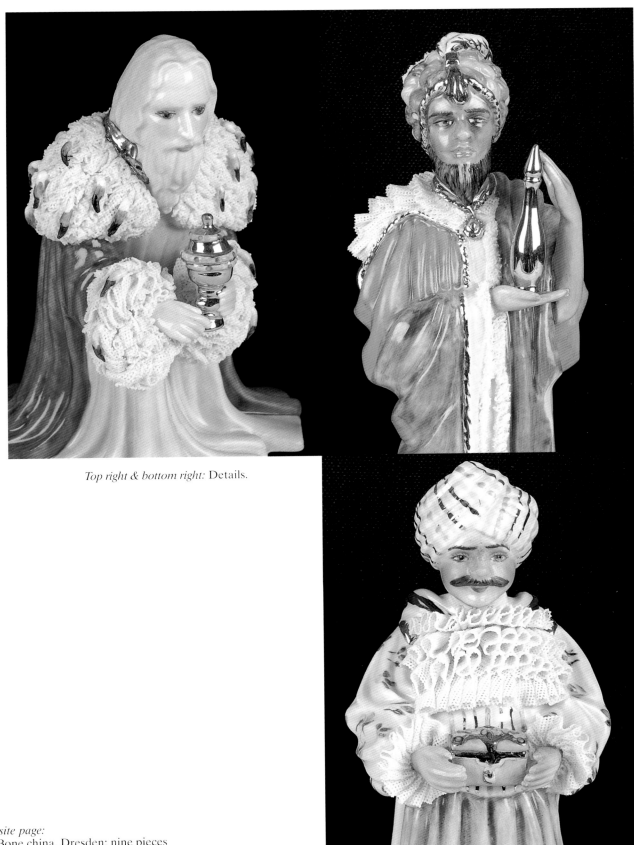

Top right & bottom right: Details.

Opposite page:
Top: Bone china, Dresden; nine pieces including kings and animals, Ireland, tallest figure 8 inches in height.

Bottom: Detail.

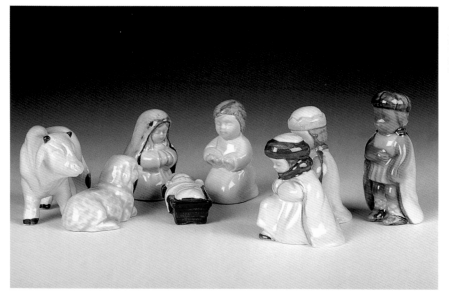

Porcelain; eight pieces including kings and animals, Germany, marked "Gobel West Germany," tallest figure 2 ¼ inches in height.

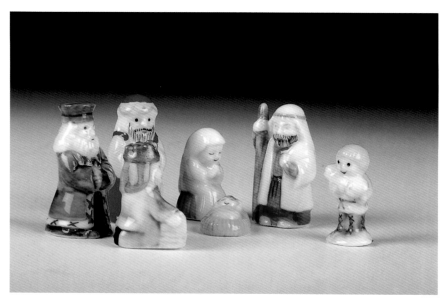

Ceramic; miniature, seven pieces including kings, shepherd, child, and animals, marked "By Bug House," tallest figure 2 inches in height.

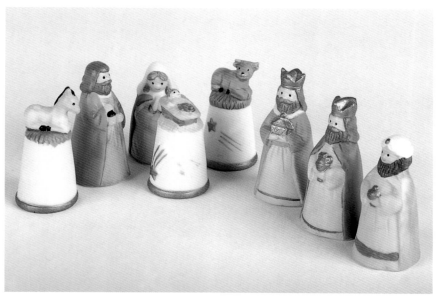

Bisque porcelain; miniature, thimbles, eight pieces including kings and animals, marked "E Mesco, made in Taiwan, R.O.C.," 1 ½ inches in height.

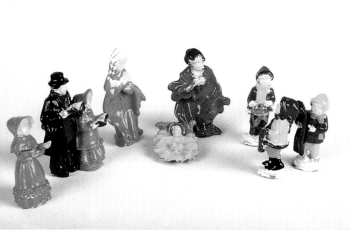

Lead; miniature, eight pieces including villagers, tallest figure ¾ inches in height.

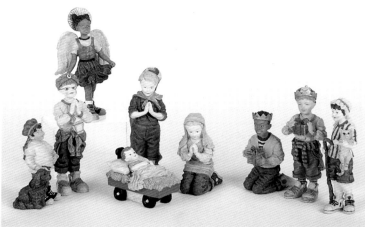

Resin; children play-acting the Nativity scene, nine pieces including angel and infant "Jesus" in a toy wagon, marked "Children of the World, Holiday Gallery," tallest piece 4 ¾ inches in height.

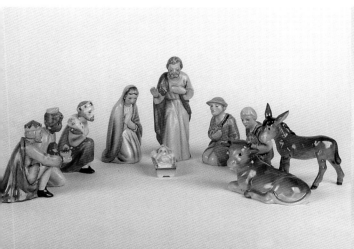

Ceramic, ten pieces including kings, shepherds, and animals, German, marked "Gobel West Germany," tallest figure 6 inches in height.

Detail.

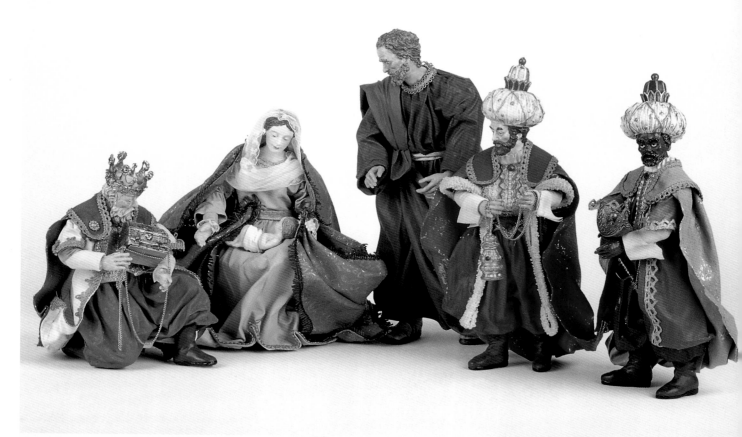

Plastic, fabric, decorative braiding; five pieces including kings, marked "Clothtique by Possible Dreams, LTD, 1989," tallest figure 10 inches in height.

Detail.

Opposite page;
Top: Clay; ten pieces including kings, shepherds, and animals, Portugal, tallest figure 13 inches in height.

Bottom right: Detail.

Bottom left: Lisbon, Portugal.

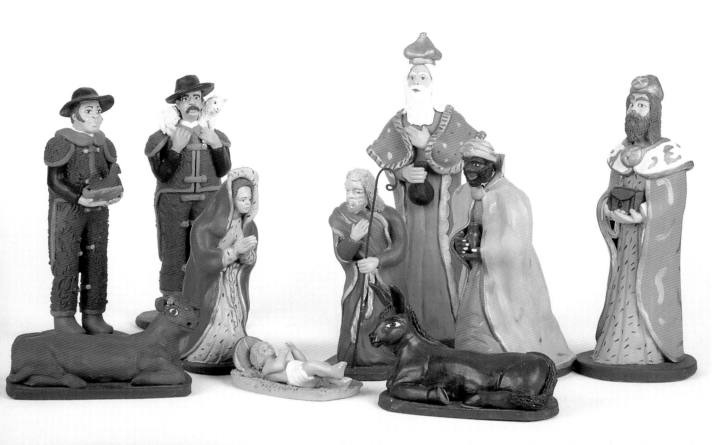

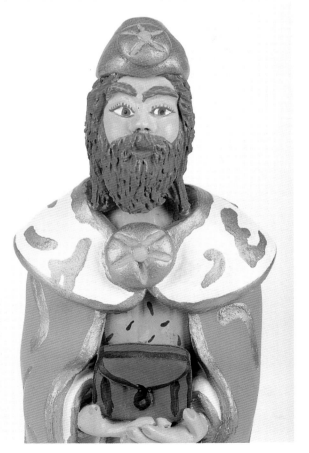

And there were shepherds in the same district living in the fields and keeping watch over their flock by night. And behold, an angel of the Lord stood by them and the glory of God shone round about them…And the angel said to them, "Do not be afraid, for behold, I bring you good news of great joy…for today in the town of David a Savior has be born to you, who is Christ the Lord. And this shall be a sign to you: you will find an infant wrapped in swaddling clothes and lying in a manger."

Luke 2: 8-12

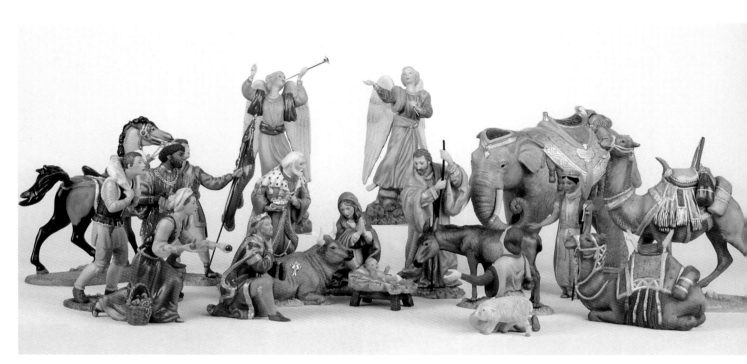

Porcelain, 24k gold; eighteen pieces including angels, kings, villagers, and animals, marked "Commissioned by Franklin Mint, The Nativity, Gianni Benvenuti, 1989," tallest figure 12 inches in height.

Detail.

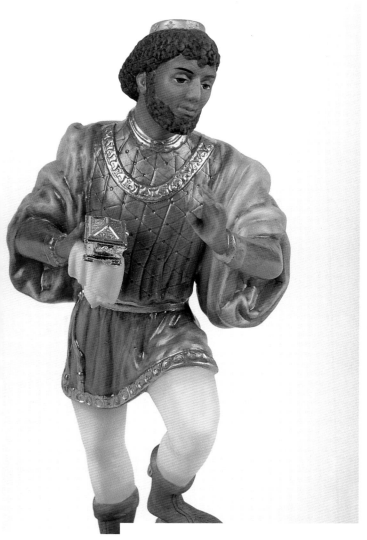

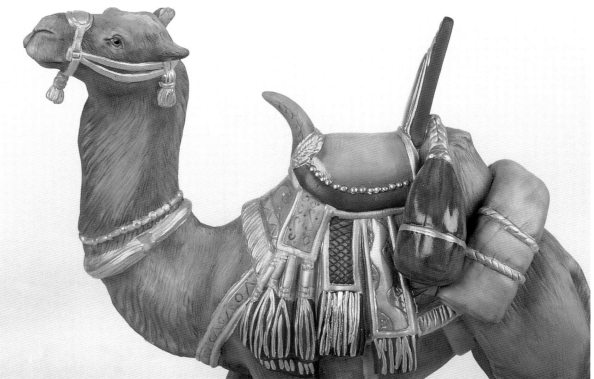

Detail.

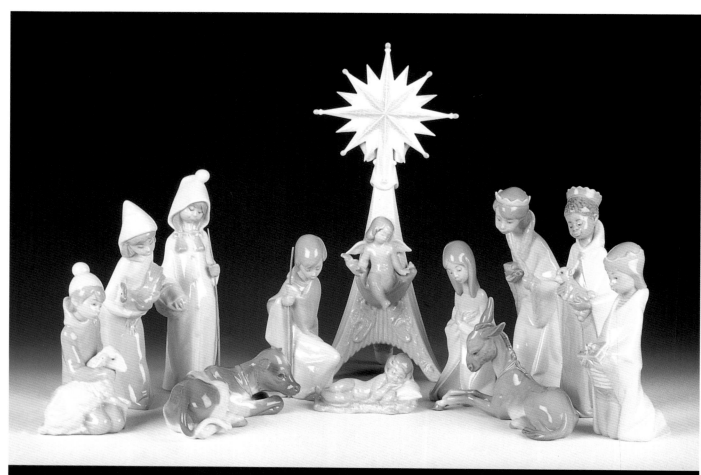

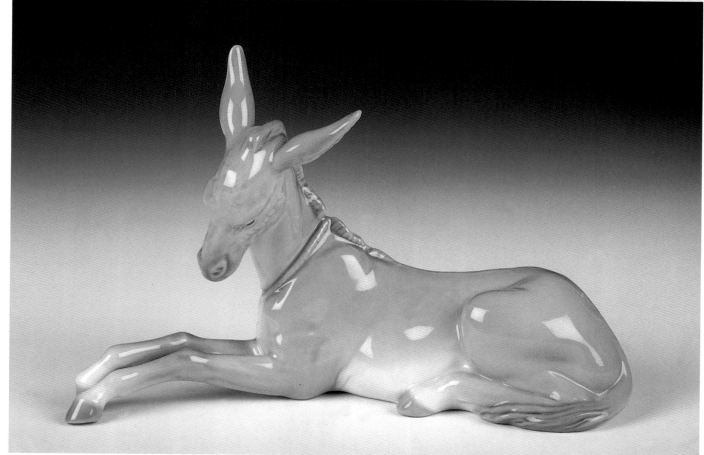

98

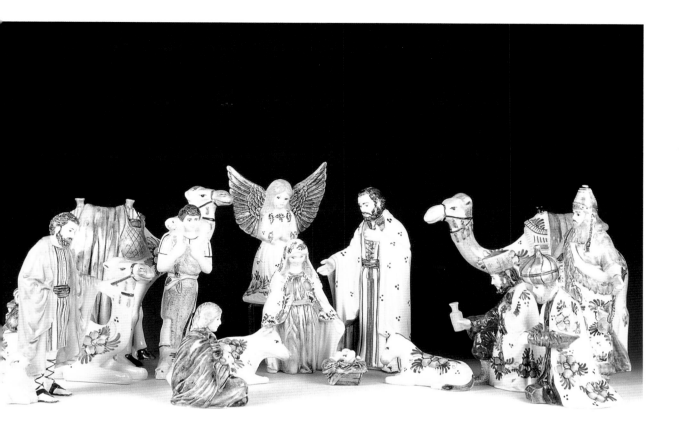

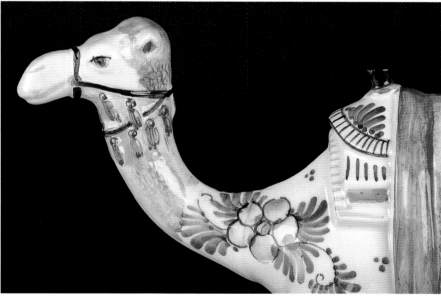

Top: Porcelain; fifteen pieces, including angel, kings, shepherds and animals, marked "Delft Polychrome, Holland, USA," tallest figure 10 inches in height.

Details.

Opposite page;
Top: Porcelain; twelve pieces, marked "Lladro," tallest piece 13 ½ inches, tallest figure 8 ½ inches in height.

Bottom: Detail.

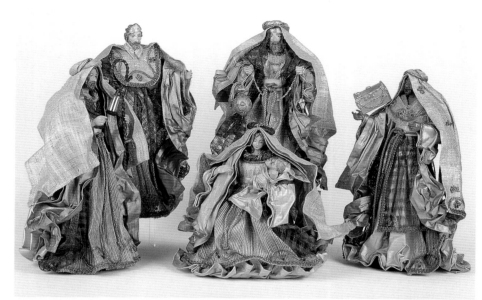

Papier mache, fabric; five pieces including three kings, marked " Winward Holidays, Hong Kong, France, Italy, USA, Canada," tallest figure 15 inches in height.

Detail.

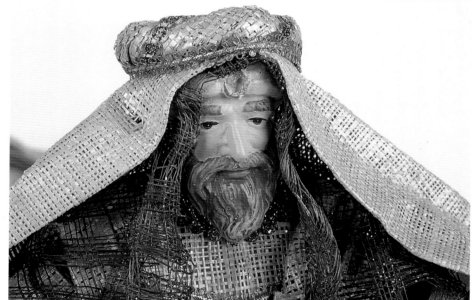

Detail.

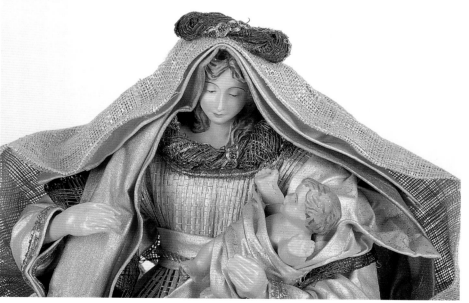

And entering the house, they found the child with Mary his mother, and falling down they worshipped him. And opening their treasures they offered him gifts of gold, frankincense and myrrh.

Matthew 2: 11

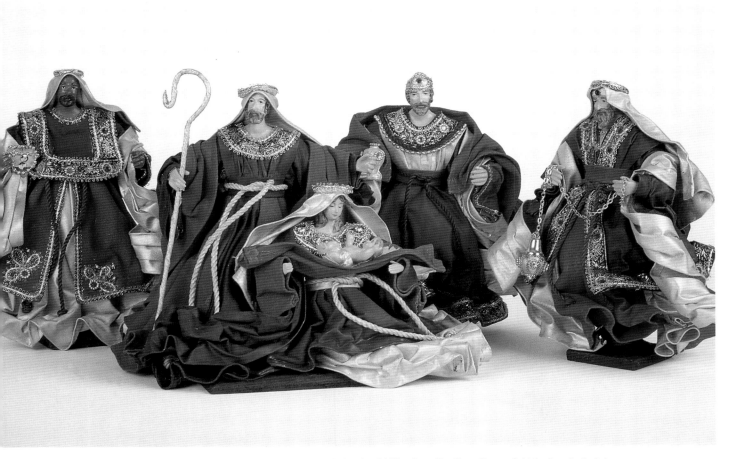

Papier mache, fabric; five pieces, marked "Made in the Philippines," tallest figure 9 ¼ inches in height.

Behold, an angel of the Lord appeared to him in a dream, saying, "Do not be afraid, Joseph, son of David, to take to thee Mary thy wife, for that which is begotten in her is of the Holy Spirit. And she shall bring forth a son, and thou shalt call his name Jesus; for he shall save his people from their sins."

Matthew 1: 20,21

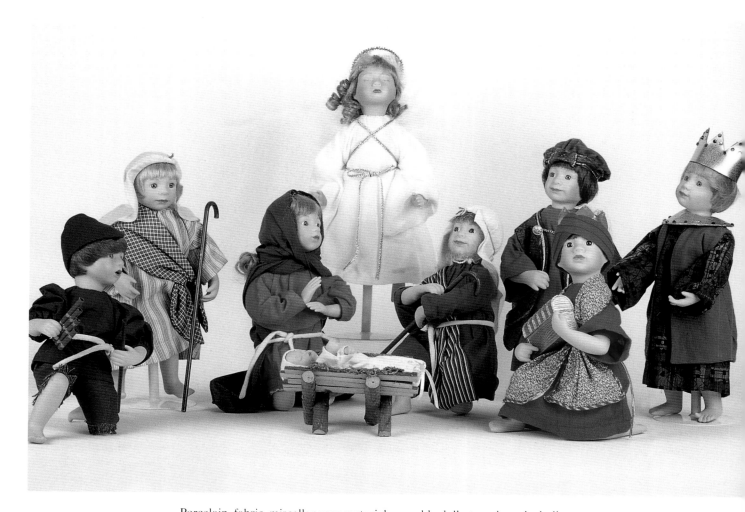

Porcelain, fabric, miscellaneous materials; posable dolls, ten pieces including angel, kings, shepherds, signed "Julie Good-Kruger," marked "The Ashton-Drake Galleries, Oh Holy Night, 1993," tallest figure 14 ½ inches in height.

Top left & top right: Details.

Ceramic, fabric; five pieces, Holy Family and angel, marked "Simple Wonders, Artaffects, LTD, 1990, made in Taiwan," tallest figure 7 ½ inches in height.

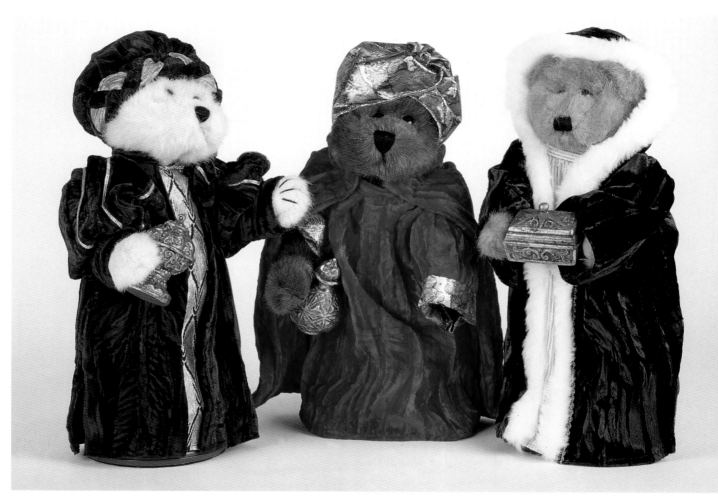

Fabric; three pieces, bear dolls as the three kings (blue robe: Melchior; maroon robe: Balthasar; green robe: Kaspar), marked "The Best of Christmas, 1999, Massachusetts," tallest figure 14 inches in height.

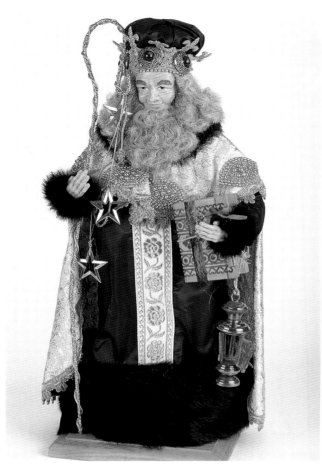

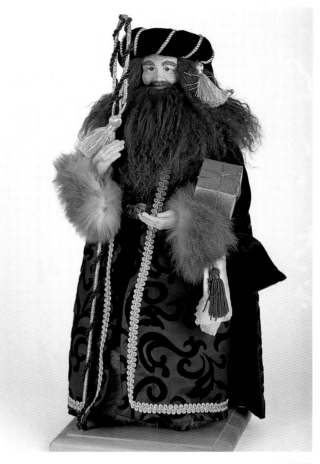

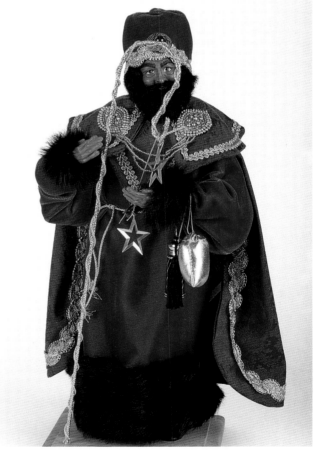

Top left; Composite, fabric; one piece of the three kings, Melchior, signed Lynn Haney, marked "Lynn Haney Collection, First Edition, LTD, 1997, Limited 1200 pieces," 18 inches in height.

Top right: Composite, fabric; one piece of the three kings, Kaspar, signed "Lynn Haney," marked Lynn Haney Collection, First Edition, LTD, 1997, Limited 1200 pieces," 18 inches in height.

Bottom right: Composite, fabric; one piece of the three kings, Melchior, signed "Lynn Haney," marked "Lynn Haney Collection, First Edition, LTD, 1997, Limited 1200 pieces," 18 inches in height.

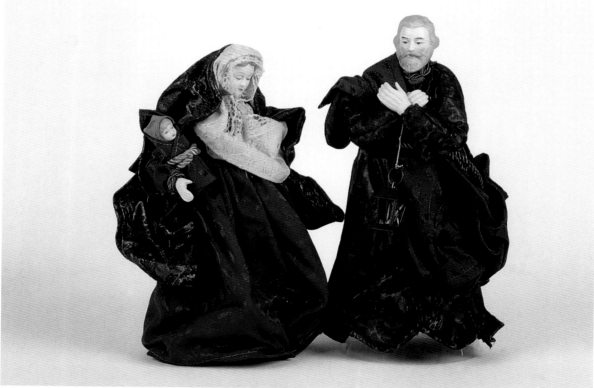

Top: Porcelain, fabric, miscellaneous materials; three posable dolls, four pieces, Holy Family, signed Brigitte Deval, marked "The Ashton-Drake Galleries, The Holy Family of the Oh Night Divine Collection 1997," tallest figure 11 inches in height.

Bottom: Porcelain, fabric; two pieces, Holy Family, 13 inches in height.

clay, fabric,
s; one-of-a-
loly Family,
gned by the
artist, Cat
er, 6 inches
in height.

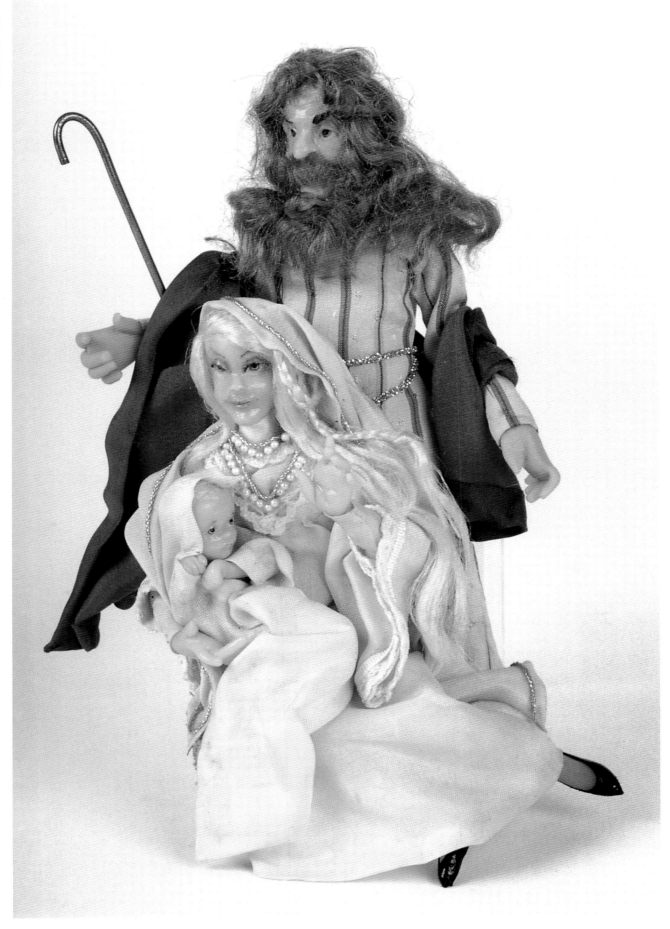

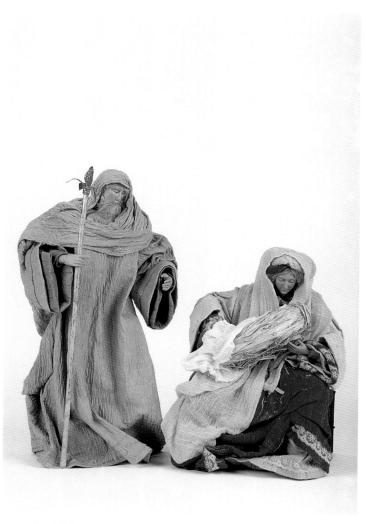

Resin, fabric, paper; two pieces, Holy Family, marked 'Made in Philippines," tallest figure 16 inches in height.

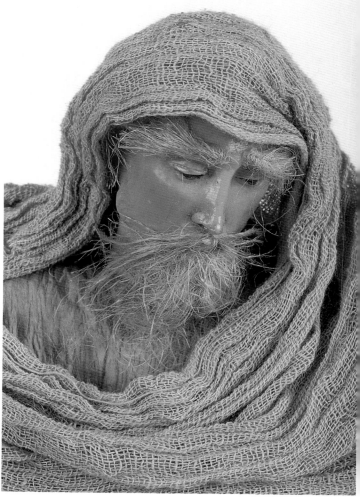

Detail.

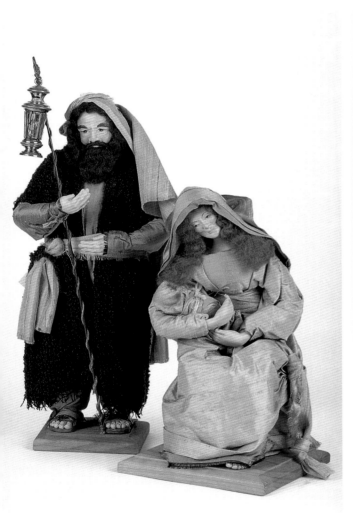

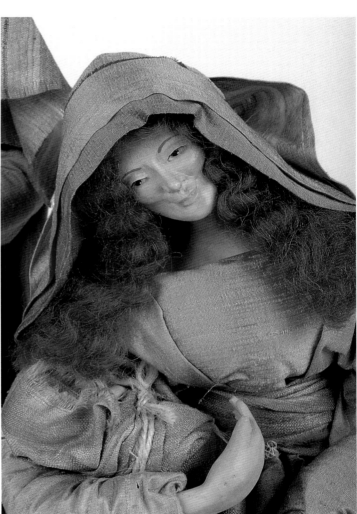

Resin, fabric, wood, brass; two pieces, Holy Family, signed "Lynn Haney," marked "Lynn Haney Collections," tallest figure 17 inches in height.

Detail.

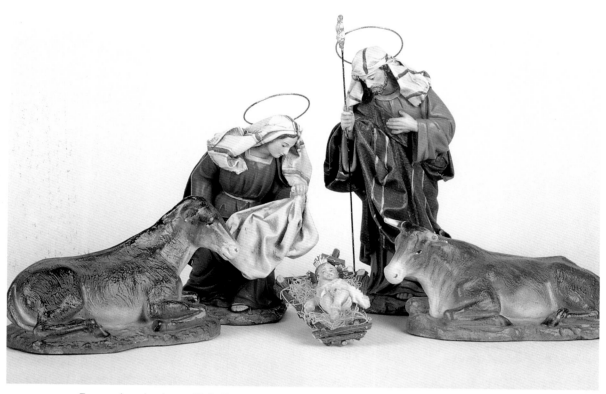

Composite; six pieces, Holy Family with animals, Spain, tallest figure 13 inches in height.

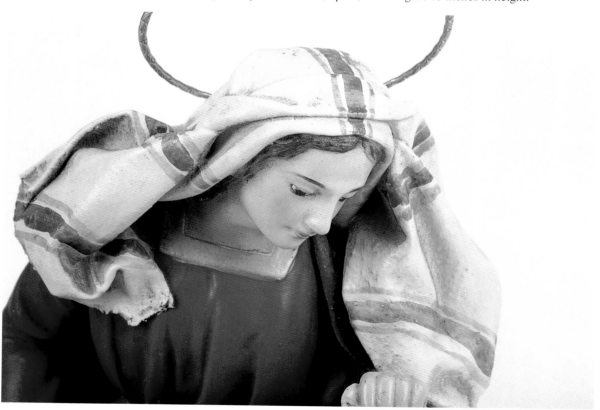

Detail.

Composite; five pieces including kings, marked "Applause, Inc. Woodland Hills, California, 1994," tallest figure 6 inches in height.

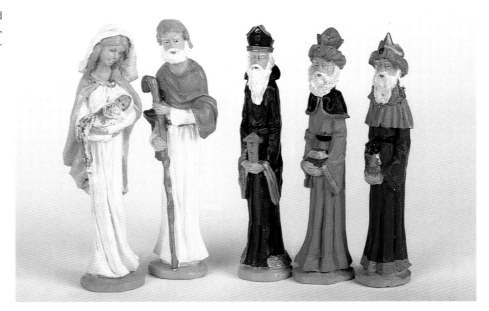

Wood, carved; ten pieces including kings and shepherds, marked "Made in China 1992," tallest figure 6 inches in height.

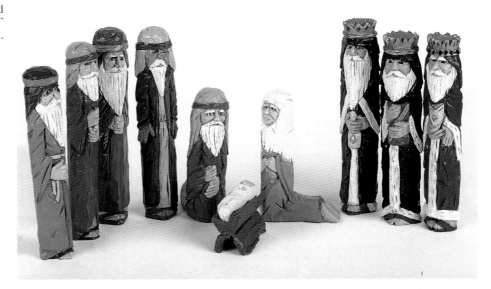

Composite; twelve pieces including angel, kings, shepherds, and animals, marked "Made by Midwest Imports," tallest figure 8 inches in height.

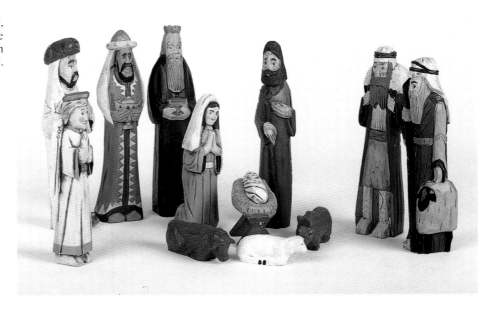

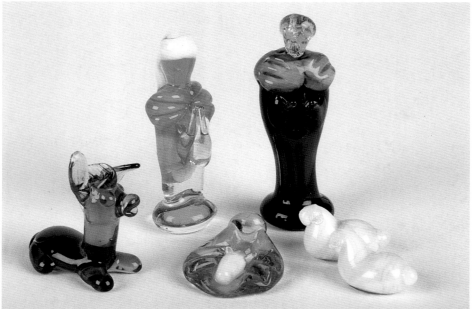

Top: Moscow, Russia.

Bottom: Glass, lamp worked; miniature, six pieces, Holy Family with animals, Russia, tallest figure 2 inches in height.

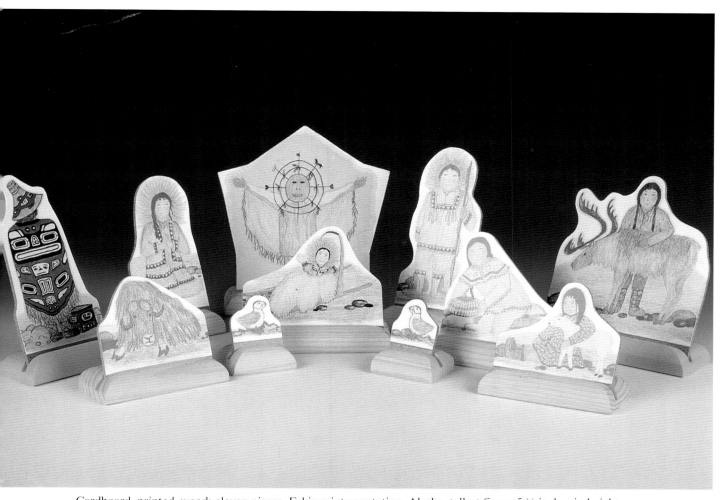

Cardboard, printed, wood; eleven pieces, Eskimo interpretation, Alaska, tallest figure 5 ½ inches in height.

Kemp Island, Alaska.

Skagway, Alaska.

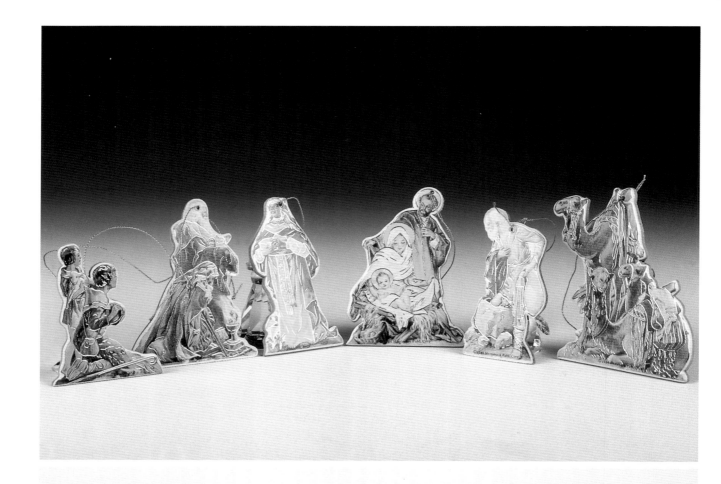

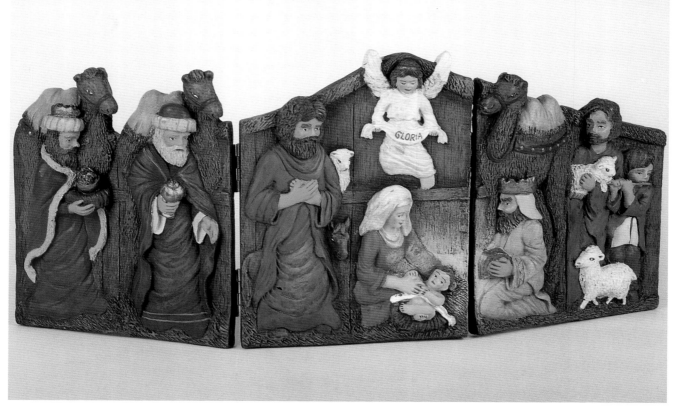

Top: Cardboard, printed; six pieces including kings, Germany, marked "Merrinack Publishing 1984," tallest figure 3 inches in height.

Bottom: Composite; three pieces, hinged panel, Holy Family with kings, 8 inches in height.

Wood, carved and brass; fourteen mounted
figures including kings and animals, signed
"Jerry Krider, 1998," 31 inches wide, 6 ½
inches in height.

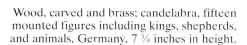

Wood, carved and brass; candelabra, fifteen
mounted figures including kings, shepherds,
and animals, Germany, 7 ¾ inches in height.

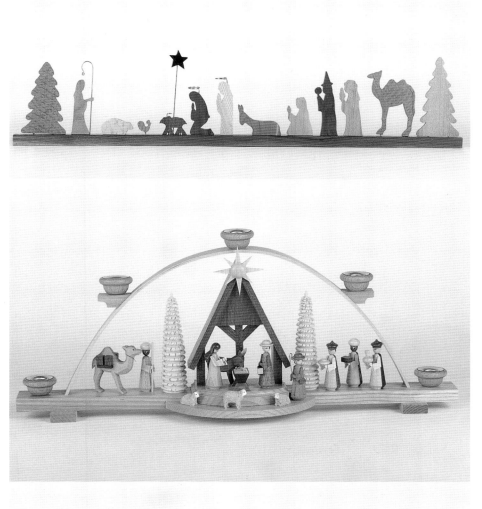

Wood, cut and twine; three sections, eighteen
puzzle pieces in woods of the region, Holy
Family with animals, Califate, Argentina, 3 ½
inches in height.

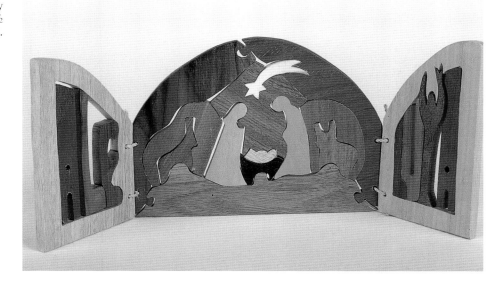

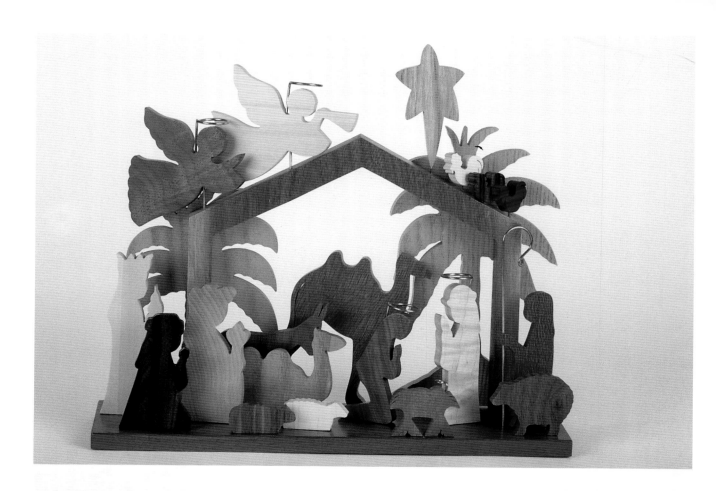

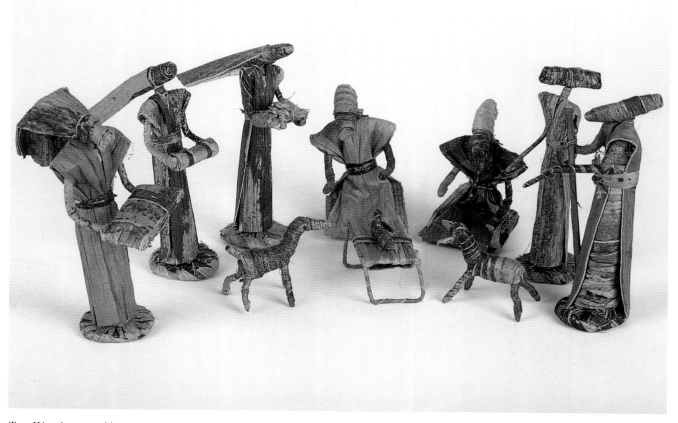

Top: Wood, cut and brass; twenty-two mounted pieces including angels, kings, shepherd, and animals, signed "Jerry Krider, 1998," 10 inches in height.

Bottom: Natural banana leaves; eleven pieces including kings, shepherds, and animals, Tanzania, Africa, 4 ½ inches in height.

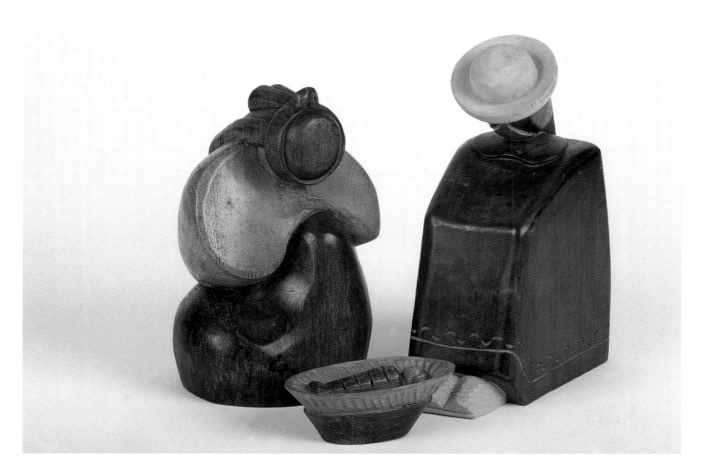

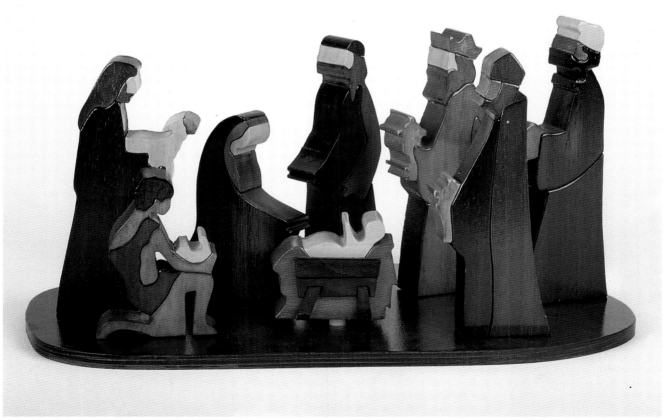

Top: Wood, carved; three pieces, Holy Family, Mexico, 9 ½ inches in height.

Bottom: Wood, carved; eight pieces mounted with pegs, including kings, shepherds, and animals, Ireland, 7 inches in height.

Pine; plaque with painted Nativity scene in form of a cross, marked "Starry Night Made in El Salvador, Vallee El Porvenir," 1 inches in height.

Wood; plaque with painted Nativity scene, marked "Midwest, Inc.," 36 inches wide, 5 ½ inches in height.

Now it came to pass in those days, that a decree went forth from Caesar Augustus that a census of the whole world should be taken . . . And all were going, each to his own town, to register. And Joseph also went from Galilee out of the town of Nazareth into Judea to the town of David, which is called Bethlehem . . . together with Mary his espoused wife, who was with child.

Luke 2: 1-5

Needlepoint, framed in wood; Nativity scene, hand-stitched by Emma Lincoln, 1995, 22 ½ inches in height.

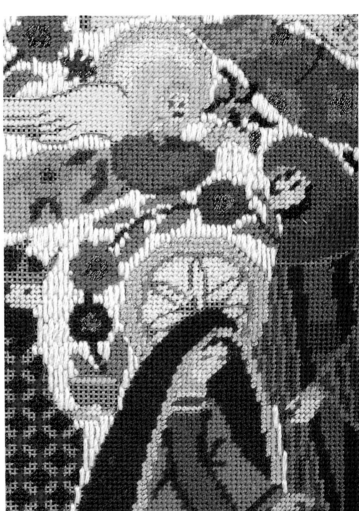

Detail.

The Magi were the travelers from the East who followed the star to the manger in Bethlehem. Frequently they are referred to as the three kings, but there is no Biblical reference to support this. They were, instead, most probably, learned men, especially in the science of astrology. Scripture does not give the country of their origin and even their number is not certain. The tradition of "three" Magi or kings grew from the triple gifts of gold, frankincense, and myrrh. The names assigned to the Magi—Gaspar, Balthasar, and Melchior—are a late tradition and are not authentic.

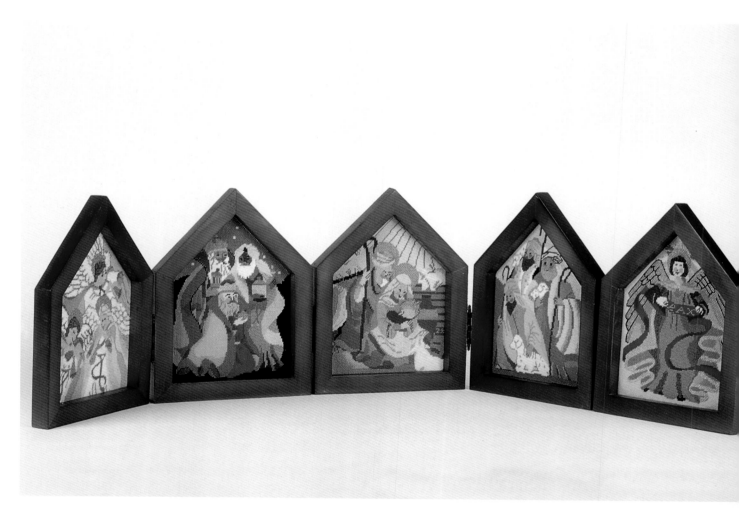

Needlepoint, framed in wood; five hinged panels, Nativity scene, hand-stitched by Emma Lincoln, 1997, 9 ½ inches in height.

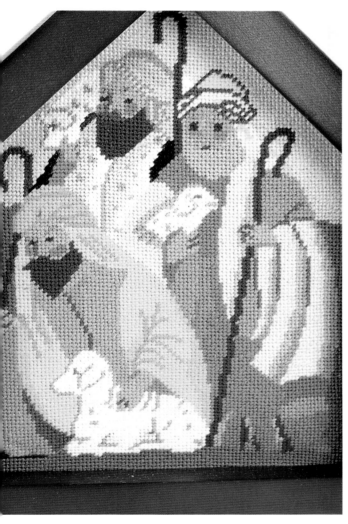

Detail.

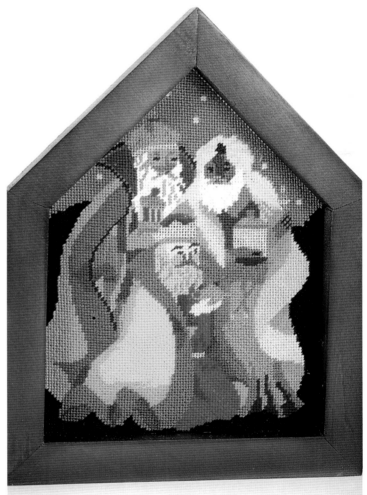

Detail.

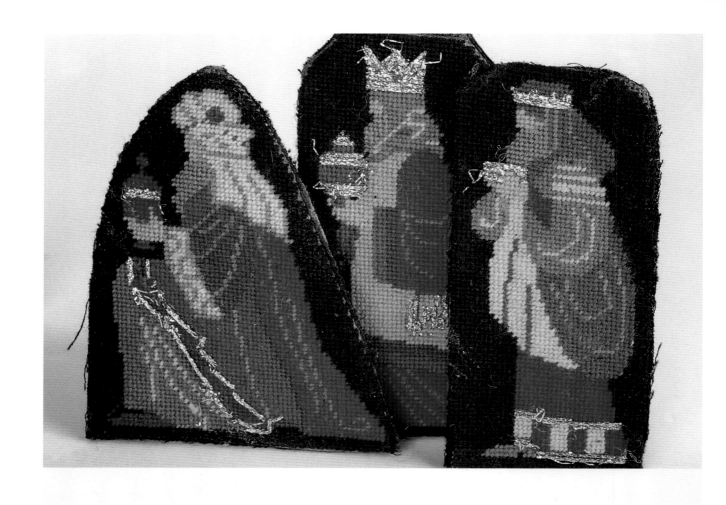

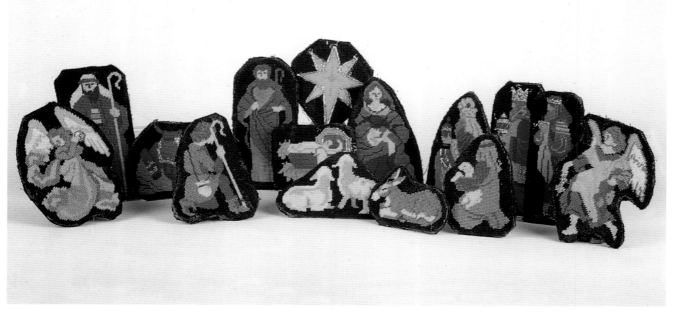

Top: Petit point; thirteen pieces, Nativity ornaments, hand-stitched by Emma Lincoln, 1994, 6 inches in height.

Bottom: Detail.

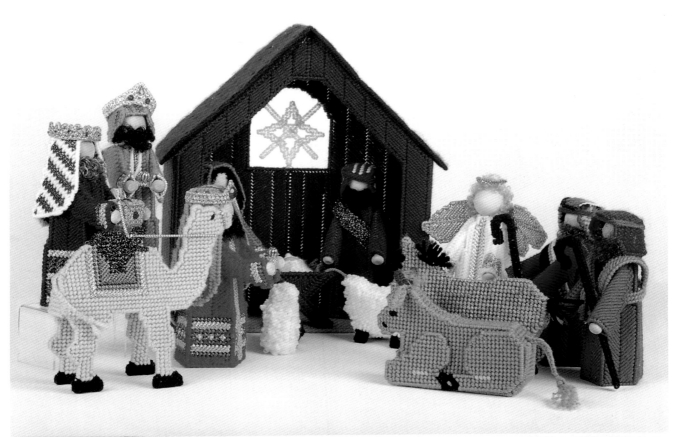

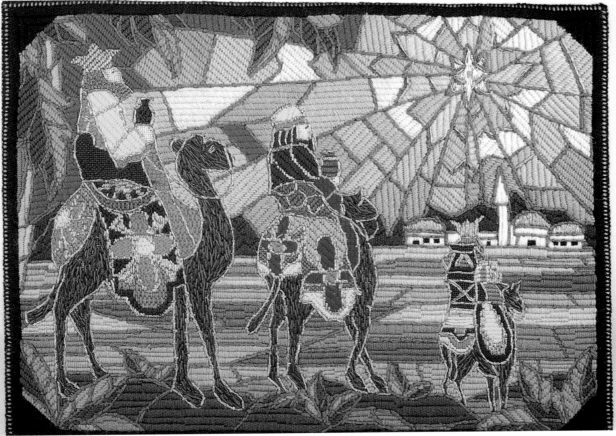

Top: Needlepoint on plastic canvas, sixteen pieces including angel, kings, shepherds, and animals, made by the students of The Clay County High School, West Virginia, for Cathy Lincoln, (Emma's daughter) 1996, 14 ½ inches in height.

Bottom: Needlepoint; a scene of The Magi (the three kings), made by Emma Lincoln, 1994, 24 inches wide, 18 ½ inches in height.

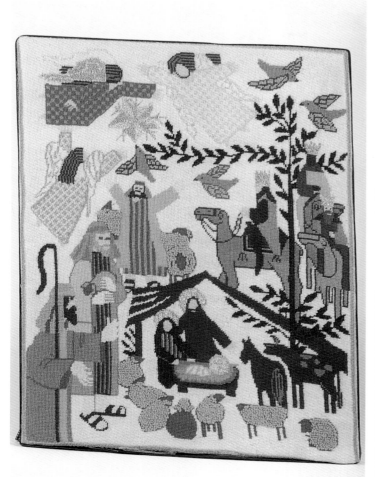

Needlepoint, framed in wood; Nativity scene, made by Emma Lincoln, 1992, 24 ½ inches in height.

Detail.

In history, a mystical significance is ascribed to the three gifts of the Magi: gold, because Christ is king; frankincense, because He is God; and myrrh, because He became man.

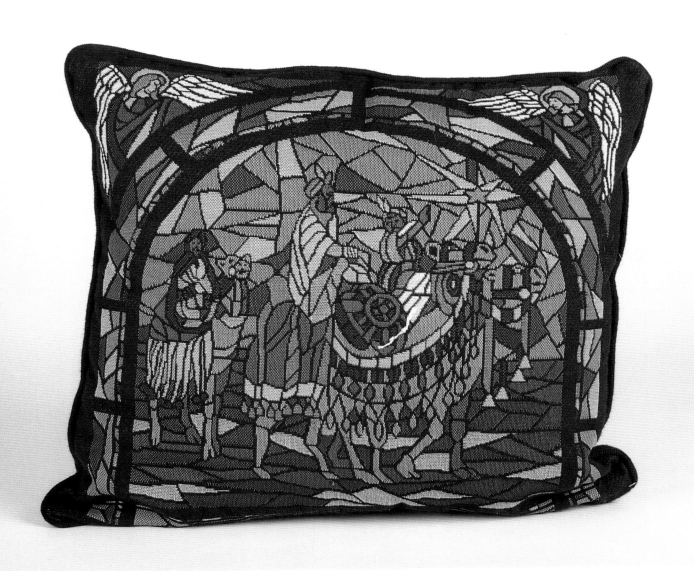

Needlepoint; pillow with the three kings following the star, commercially made, 18 x18 inches.

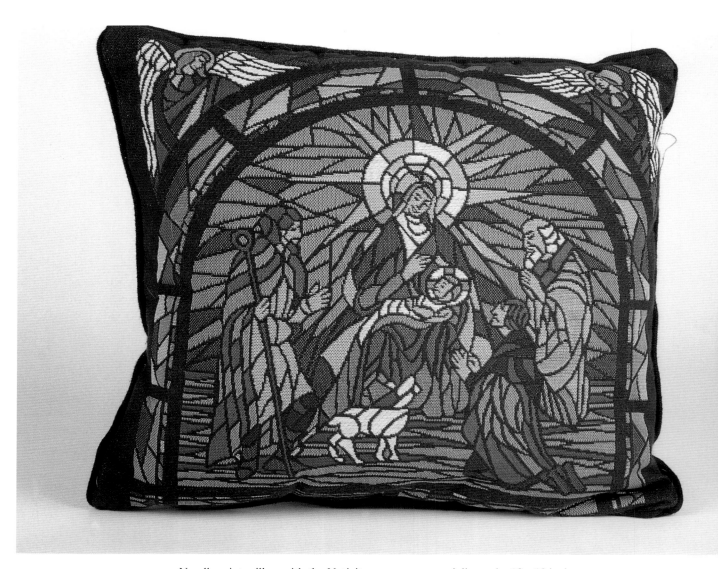

Needlepoint, pillow with the Nativity scene, commercially made, 18 x 18 inches.

And suddenly there was with the angel a multitude of heavenly host praising God and saying, "Glory to God in the highest, and on earth peace among men of good will."

Luke 2: 13, 14

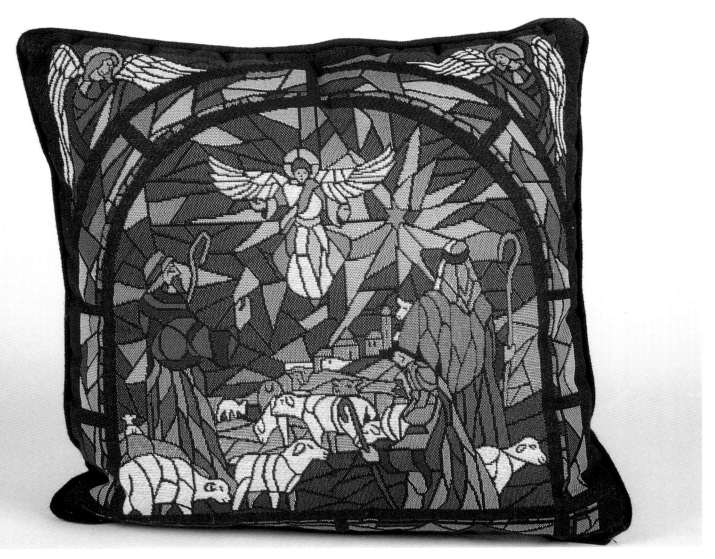

Needlepoint; pillow with the shepherds following the star, commercially made, 18 x 18 inches.

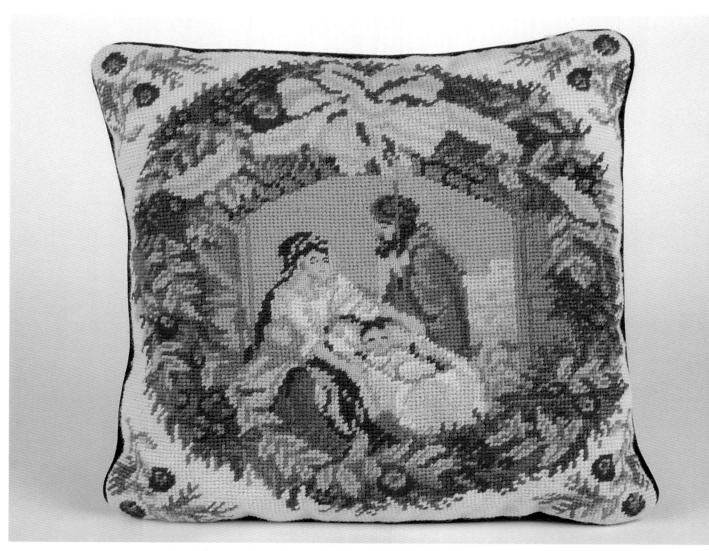

Needlepoint; pillow with the Nativity scene, commercially made, 12 x 12 inches.

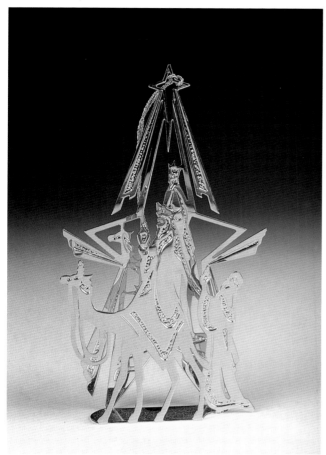

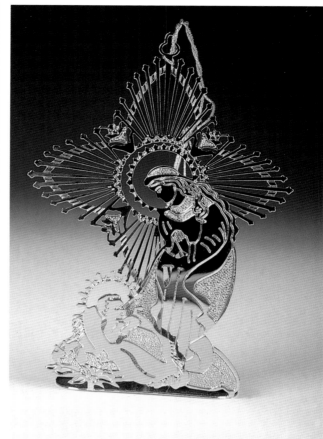

Top left: Brass; ornament, the three kings following the star, marked "Danbury Mint, 1988," 4 inches in height.

Top right: Brass; ornament, Mary and the infant Jesus, marked "Danbury Mint, 1989," 2 ½ inches in height.

Bottom right: Brass; ornament, the three kings on camels, marked "Danbury Mint, 1991," 4 inches in height.

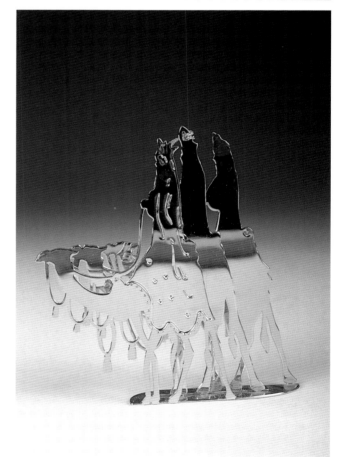

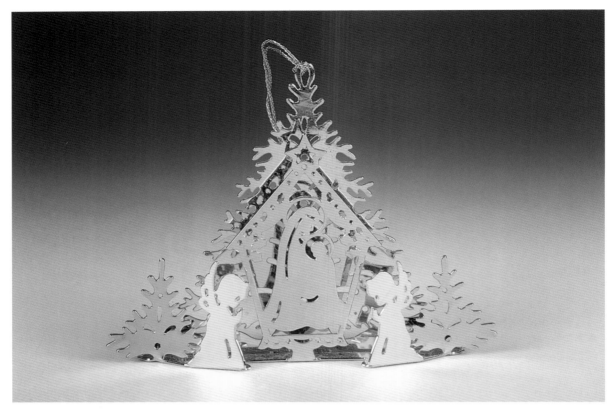

Brass; ornament, the Nativity scene, marked "Danbury Mint, 1985," 3 inches in height.

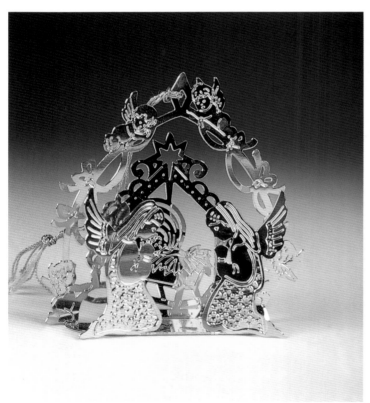

Brass; ornament, the Nativity scene, marked "Danbury Mint, 1991," 2 ½ inches in height.

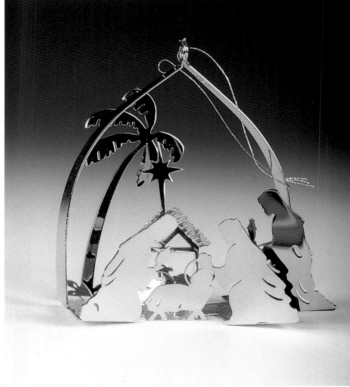

Gold, electroplated; the Nativity scene, marked "Lunt," 3 inches in height.

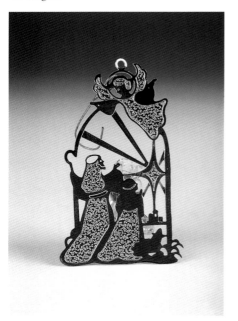

Brass; ornament, the shepherds
following the star, marked
"Danbury Mint, 1989," 2 ¾ inches
in height.

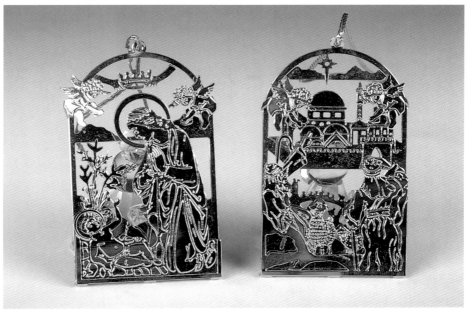

Brass; two ornaments, *left*: the Nativity
scene; *right*: the shepherds following the
star, 2 inches in height.

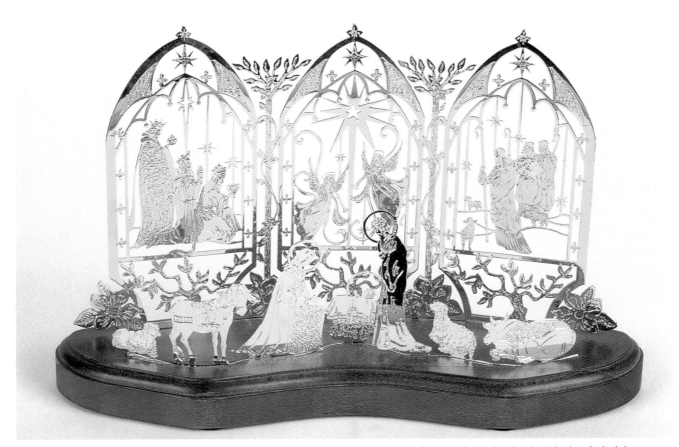

Brass, 24k gold finish, walnut base; eight pieces mounted, the Holy Family, angels, and animals, 6 inches in height.

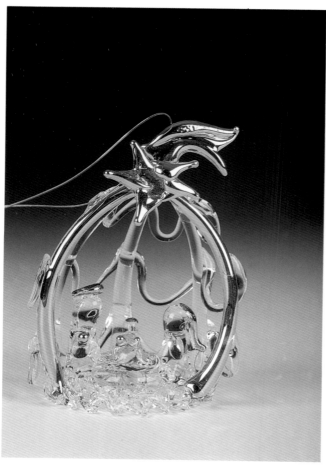

Glass, lamp worked and gold; ornament, the Holy Family, marked "Made in China," 3 inches in height.

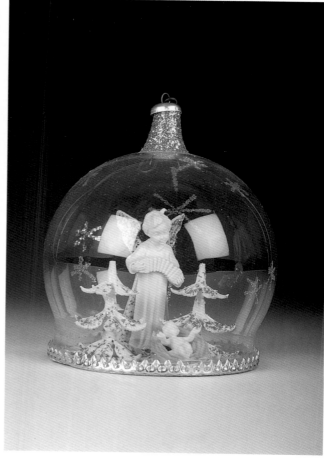

Glass, blown and plastic figures; ornament, angel with the infant Jesus, 4 inches in height.

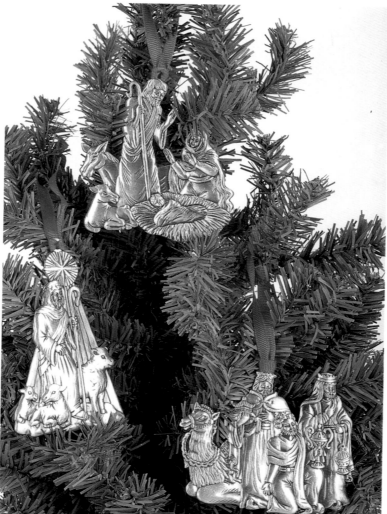

Pewter; three ornaments, the Holy Family, the three kings, a shepherd and animals, 3 ½ inches wide, 3 inches in height.

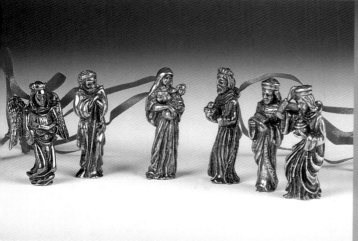

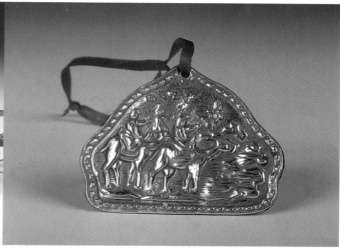

ilver-plated; six ornaments, figures of Holy Family, angel, and
ings, marked "Reed & Barton," 1 ¾ inches in height.

Sterling silver, hammered; ornament, the three kings, marked
"Made in Greece," 2 inches in height.

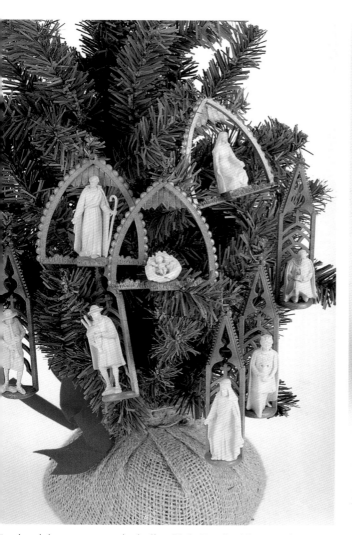

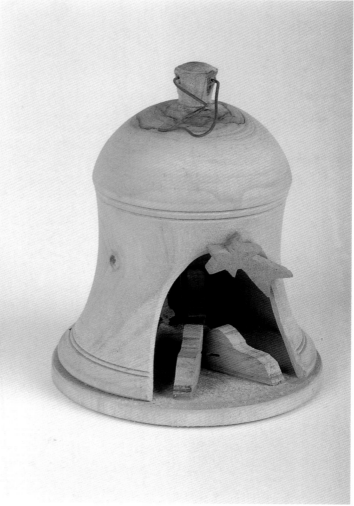

astic; eight ornaments, including Holy Family, kings, and
epherds, 3 inches in height.

Wood, turned and cut; figures of Holy Family and animals
mounted in bell shape, marked "Made in Bethlehem," 4 inches in
height.

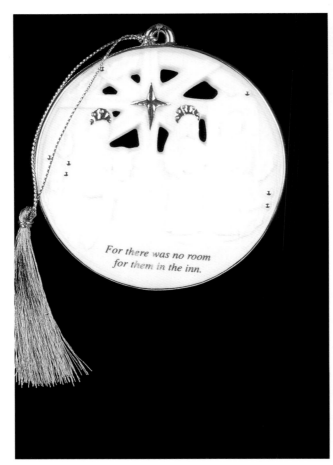

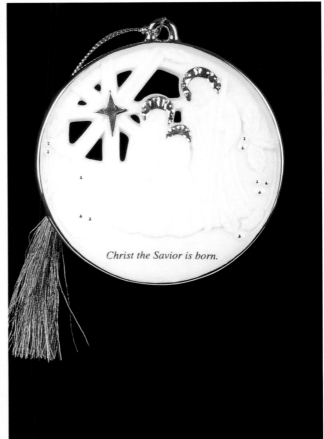

Top left: Porcelain, bas-relief, gold; ornament, "For there was no room for them at the inn," Mary on a donkey, Joseph and inn keeper, marked "The Millennium Nativity Ornament Collection, Limited Edition, Lenox, hand crafted in China," 5 inches in diameter.

Top right: Porcelain, bas-relief, gold; ornament, "Christ the Savior is born," the nativity scene, marked "The Millennium Nativity Ornament Collection, Limited Edition, Lenox, hand crafted in China," 5 inches in diameter.

Bottom right: Porcelain, bas-relief, gold; ornament, "The stars in the sky looked down where he lay," infant Jesus and animals, marked "The Millennium Nativity Ornament Collection, Limited Edition, Lenox, hand crafted in China," 5 inches in diameter.

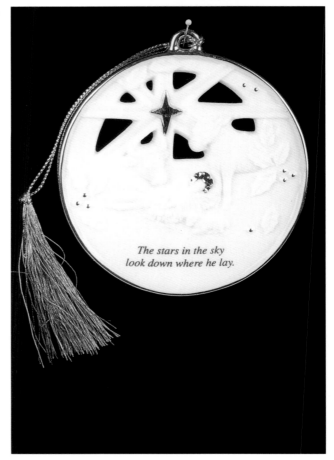

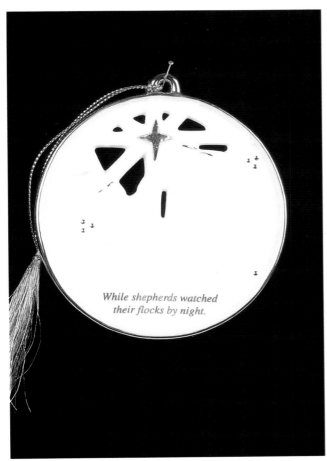

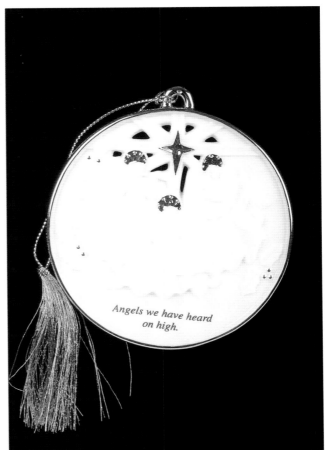

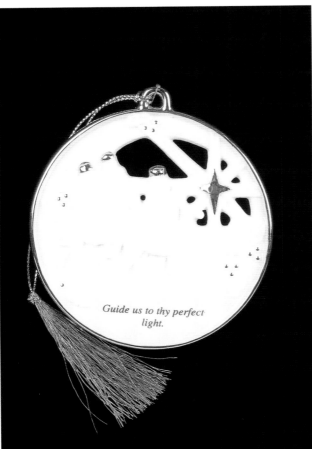

Top left: Porcelain, bas-relief, gold; ornament, "While shepherds watched their flock at night," shepherds looking at the star, marked "The Millennium Nativity Ornament Collection, Limited Edition, Lenox, hand crafted in China," 5 inches in diameter.

Top right: Porcelain, bas-relief, gold; ornament, "Angels we have heard on high," three angels and the star, marked "The Millennium Nativity Ornament Collection, Limited Edition, Lenox, hand crafted in China," 5 inches in diameter.

Bottom left: Porcelain, bas-relief, gold; ornament, "Guide us to thy perfect light," the three kings following the star, Marked "The Millennium Nativity Ornament Collection, Limited Edition, Lenox, hand crafted in China," 5 inches in diameter.

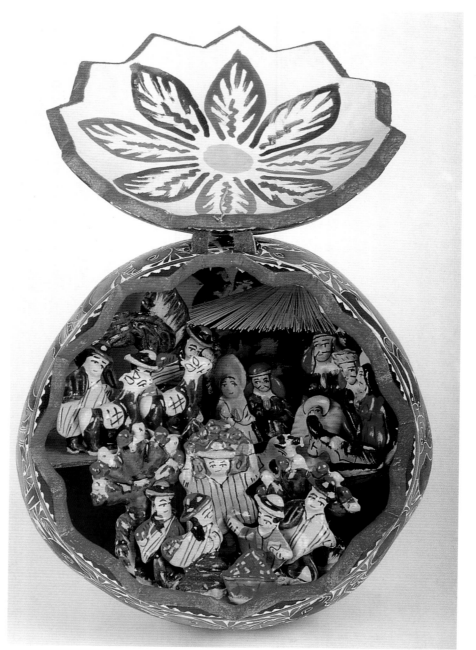

Natural gourd, cut; incised box, South American interpretation, animals at the Nativity scene, Peru, 6 inches in height.

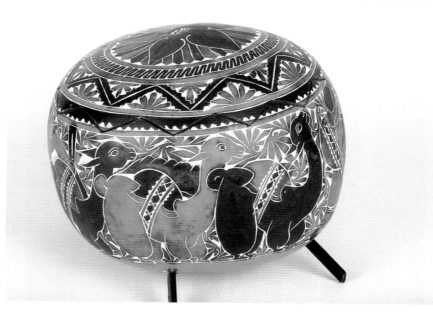

Detail: natural gourd box opened to display Nativity scene in papier mache figures.

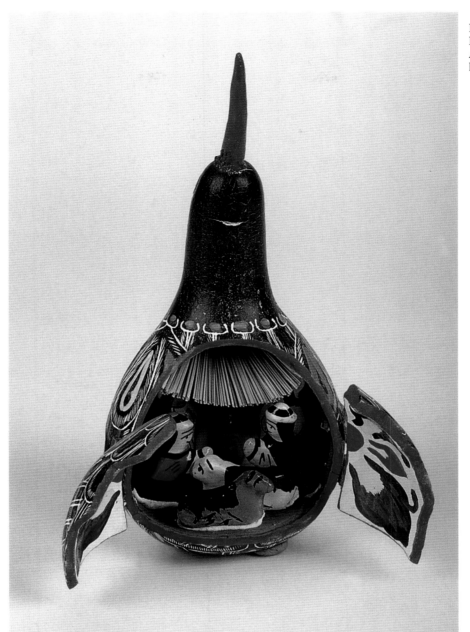

Natural gourd, incised;
Nativity scene, South
America, 4 inches in
height.

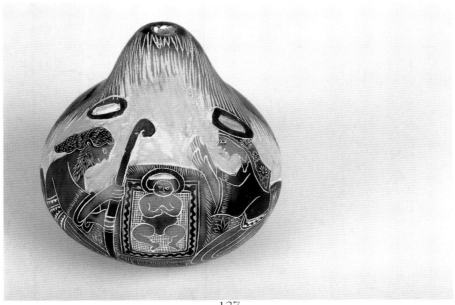

Natural gourd, cut,
incised; open to display
papier mache figures of
the Holy Family, 7
inches in height.

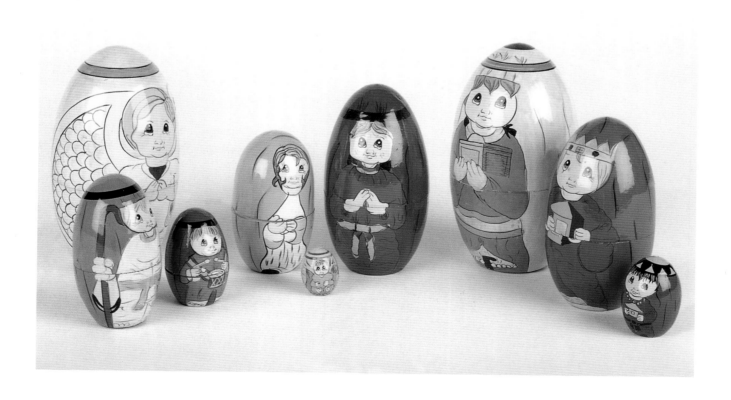

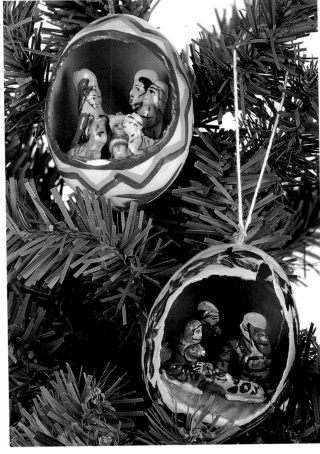

Opposite page;
Top left: Moscow, Russia.

Top right: Moscow, Russia.

Bottom: Wood; nine egg-shaped nesting dolls, children dressed as angel, kings, and shepherds, Matruska dolls, Russia, marked "Our Christmas Show," 5 inches in height.

Right: Natural egg shell, papier mache; two ornaments with Nativity scene, Peru, 2 inches in height.

Bottom left: Glass, blown with reverse painting; five egg-shaped ornaments including Holy Family, angel, kings, 3 ¼ inches in height.

Bottom right: Detail.

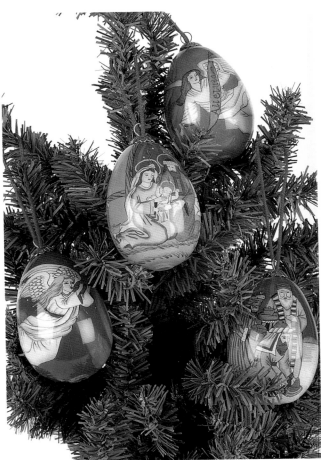

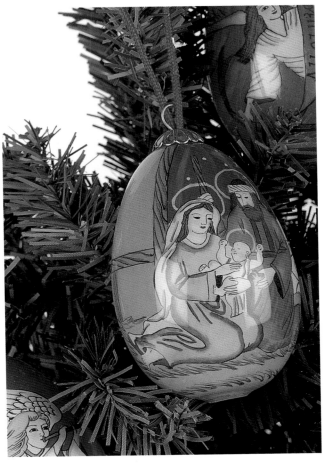

Glass, blown with reverse painting; eight round ornaments, from a set of twelve, the nativity scene, marked "Bethlehem Series, Salt of the Earth International Treasures," 3 inches in diameter.

Opposite page;
Top left: Glass, blown; six ornaments including figures of Holy Family, kings, and shepherd, marked "Kurt S. Adler, Inc. Polonaise Collection, New York," 7 inches in height.

Top right: Detail.

Bottom left: Glass, blown; five ornaments including figures including figures of Holy Family and kings, marked "Lauscha Glas Creation, original Christbaumschmuck aus dem Thuringerwald," Germany, 5 inches in height.

Bottom right: Olive wood; glass; composite; four ornaments with Nativity scene, 4 inches and 2 inches in height.

Detail: the Holy Family.

Detail: the three kings on camels following the star.

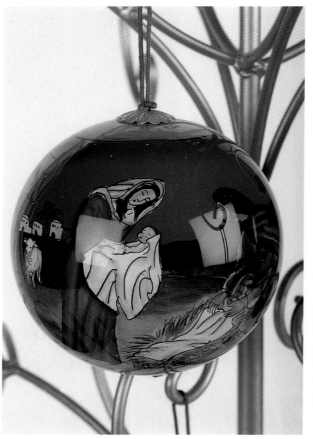

140

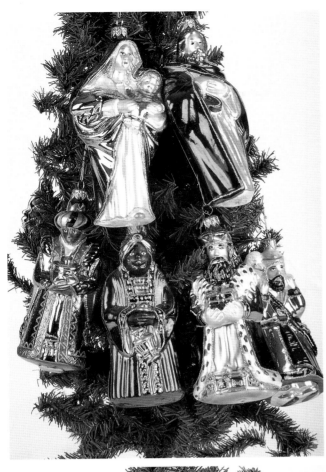

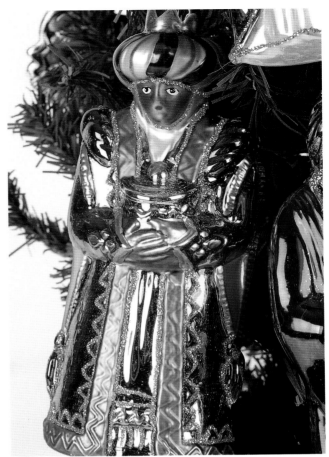

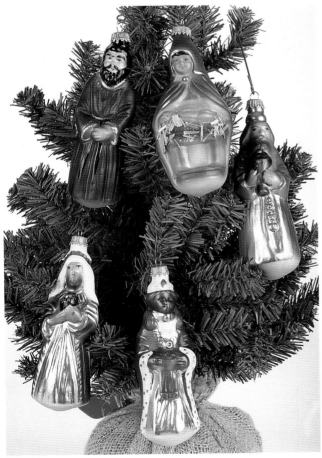

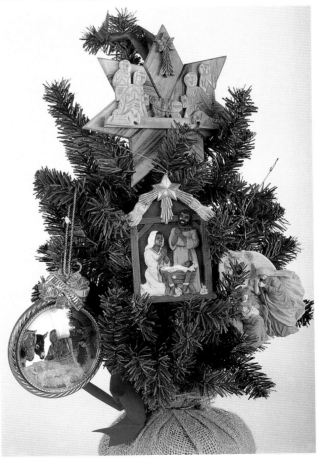

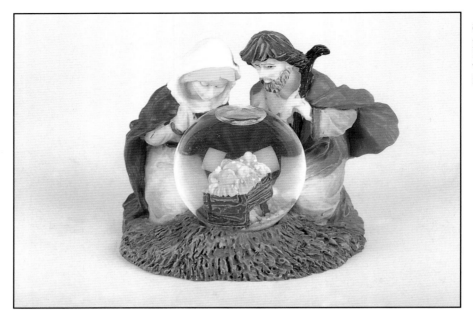

Composite, glass; one piece includes Holy Family, infant Jesus in "snow globe," 3 ½ inch in height.

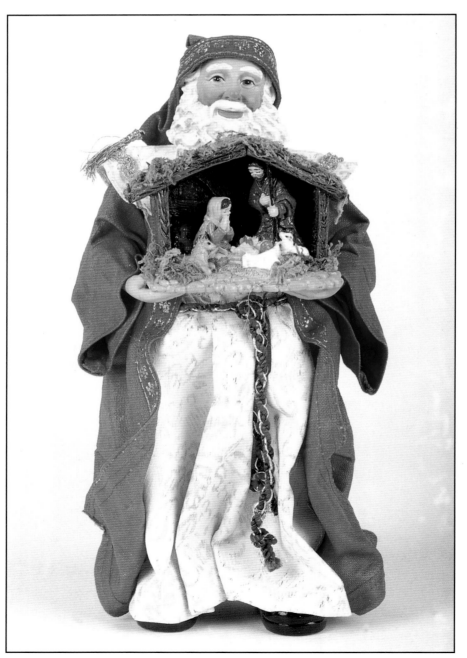

Composite, fabric; "Santa Claus" holding miniature Crèche, marked "Clothique by Possible Dreams Limited, 1997," 12 inches in height.

Bibliography

Holy Bibly. Reverend John P. O'Connell, ed. Chicago, Illinois: The Catholic Press, Inc., 1950.

Metropolitan Museum of Art. *The Nativity: the Christmas Crèche at the Metropolitan Museum of Art*. New York: Doubleday & Company, Inc., 1965, 1969.

Smith, Lissa and Dick. *Christmas Collectibles: A Guide to Selecting, Collecting and Enjoying the Treasures of Christmas Past*. New Jersey: Chartwell Books, 1993.

Vita, Emilio. *Il Presepio*. Ravena, Italy: Danilo Montanari, 1991.

Whitmyer, Margaret and Kenn. *Christmas Collectibles*, Second Edition. Kentucky: Collector Books, 1994.

Wood, Jeremy. *The Nativity: Themes in Art*. London: Scala Publications Ltd, 1991.

Index of Cultural Interpretations

Value Guide

This guide is to provide an estimate of the retail value of the Nativity scenes shown in the book. It is only an estimate, and neither the author nor the publisher is responsible for any outcomes from consulting it. The real value, however, is not monetary; it is the spiritual and aesthetic value and pleasure derived from these delightful works of art.

Abbreviations: **T**=top; **B**=bottom; **C**=center; **L**=left; **R**=right

p. 6: $125-250
p. 7: T $175-250
 BL $75-100
 BR $125-150
p. 8: $175-225
p. 9: TL $425-525
 TR $75-125
p. 10: T $25-30
 B $25-30
p. 11: C $875-1200
p. 12: T $25-35
 C $250-300
 B $25-35
p. 13: B $1200-1800
p. 14: B $175-225
p. 15: TL $300-500
 TR $725-800
p. 16: T $400-600
p. 17: TL $500-950
 TR $35-60
 B $350-525
p. 18: T $30-45
p. 19: TL $25-35
 TR $25-35
 BL $5-12
 BR $75-90
p. 20: TL $25-45
 TR $60-80
 B $75-100
p. 21: L $30-45
 R $20-40
p. 22: B $30-45
p. 23: T $12-18
 C $10-15
 B $8-12
p. 24: L $25-35
R $35-50
p. 25: T $30-45
 BL $25-40
p. 26: TL $55-75
 TR $80-125
BL $55-75
p. 27: TL $45-65
 TR $25-35
 B $6-10
p. 28: TL $20-30
 TR $35-50
p. 29: T $20-25
 BL $15-20
 BR $15-20
p. 30: T $1500-2500
p. 32: B $95-125
p. 33: B $45-95
p. 34: B $120-150
p. 35: T $35-50
 C $350-500
 B $350-500

p. 36: T $200-350
 B $250-450
p. 37: B $175-225
p. 38: T $75-125
 B $100-150
p. 39: T $100-150
p. 40: T $45-60
 B $250-300
p. 41: T $40-65
 B $25-35
p. 42: TL $35-50
 TR $150-250
 B $400-500
p. 43: T $45-70
p. 44: T $20-30
 C $50-75
 B $100-200
p. 45: $150-225
p. 46: TL $35-60
 TR $50-75
 B $9-15
p. 47: T $35-45
 C $150-200
 B $95-125
p. 48: TL $20-30
 TR $15-20
 B $15-20
p. 49: TL $250-300
 TR $190-225
p. 50: TL $35-50
 TR $140-160
 BL $140-160
 BR $150-175
p. 51: T $25-35
 B $35-50
p. 52: $75-125
p. 53: T $25-35
 C $15-20
 B $35-45
p. 54: T $8-12
 C $300-500
 B $100-125
p. 55: T $95-125
 B $35-50
p. 56: T $30-45
 B $175-200
p. 57: L $145-200
 R $35-45
p. 58: TL $30-40
 TR $25-35
 B $35-45
p. 59: T $900-1200
p. 60: T $25-35
p. 61: T $60-100
 C $45-70
p. 62: T $600-1000
p. 63: T $50-75

 C $50-75
p. 64: T $300-500
p. 65: T $300-500
p. 66: T $350-400
p. 67: T 150-200
p. 68: T $975-1000
 B $60-75
p. 69: T $65-75
 C $35-50
 B $60-75
p. 70: T $300-500
 B $30-40
p. 71: B $195-250
p. 72: T $35-50
 B $15-20
p. 73: T $200-250
 C $75-85
 B $100-125
p. 74: T $200-250
 B $125-150
p. 75: T $60-75
 B $8-12
p. 76: T $200-250
p. 77: T $100-125
 C $50-65
 B $25-30
p. 78: $240-275
p. 80: $75-100
p. 81: T $18-25
 B $35-45
p. 82: $200-250
p. 84: B $100-125
p. 85: B $100-125
p. 86: T $55-75
 B $35-50
p. 87: C $200-250
p. 88: T $30-40
 B $15-20
p. 89: $160-175
p. 90: T $1900-2200
p. 92: T $450-550
 C $35-45
 B $30-45
p. 93: TL $10-15
 TR $90-125
 BL $200-250
p. 94: T $50-75
p. 95: T $75-100
p. 96: $1500-1800
p. 98: T $2000-3000
p. 99: T $1000-1300
p. 100: T $125-150
p. 101: $90-120
p. 102: $800-1200
p. 103: B $125-150
p. 104: $800-1200
p. 106: T $200-250

p. 107: $300-500
p. 108: L $175-200
p. 109: L $800-1000
p. 110: T $225-300
p. 111: T $100-150
 C $50-75
 B $100-125
p. 112: B $18-25
p. 113: T $35-50
p. 114: T $25-30
 B $50-75
p. 115: T $150-200
 C $150-200
 B $40-60
p. 116: T $180-225
 B $45-65
p. 117: T $30-45
 B $75-125
p. 118: T $25-35
 B $75-100
p. 125: $50-75
p. 126: $50-75
p. 127: $50-75
p. 128: $40-60
p. 129: TL $15-20
 TR $15-20
 B $15-20
p. 130: T $15-20
BL $15-20
 BR $15-20
p. 131: TL $15-20
 TR $8-10 each
 B $90-125
p. 132: TL $15-20
 TR $15-20
 B $15-20 each
p. 133: TL $15-20 each
 TR $30-45
 BL $5-8 each
 BR $15-20
p. 134: TL $20-25
 TR $20-25
 B $20-25
p. 135: TL $20-25
 TR $20-25
 B $20-25
p. 136: B $40-50
p. 137: B $15-20
p. 138: B $10-15
p. 139: TR $20-25 each
 BL $75-100
p. 140: T $55-75
p. 141: TL $20-25 each
 BL $15-20 each
 BR $10-15 each
p. 142: T$50-75
 B $25-50